RIVERHEAD BOOKS
NEW YORK
2017

Blitt

(By Barry Blitt)

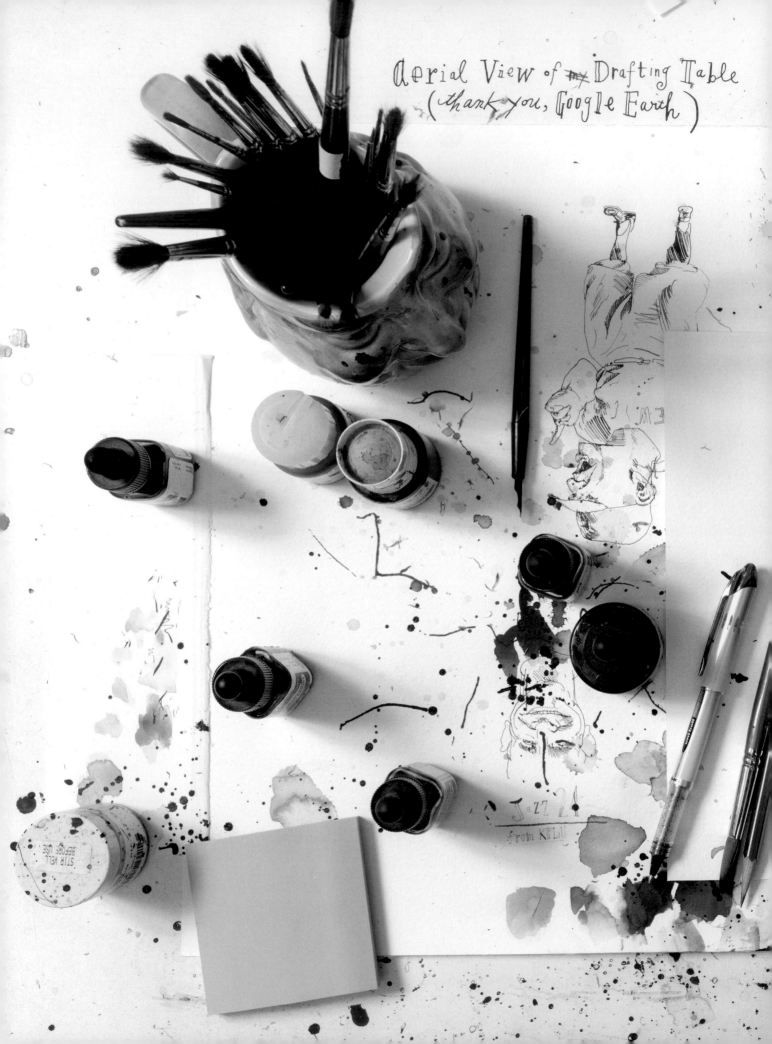

Aerial View of ~~my~~ Drafting Table
(thank you, Google Earth)

Jazz 24
from KPLU

STIR WELL
BEFORE USE

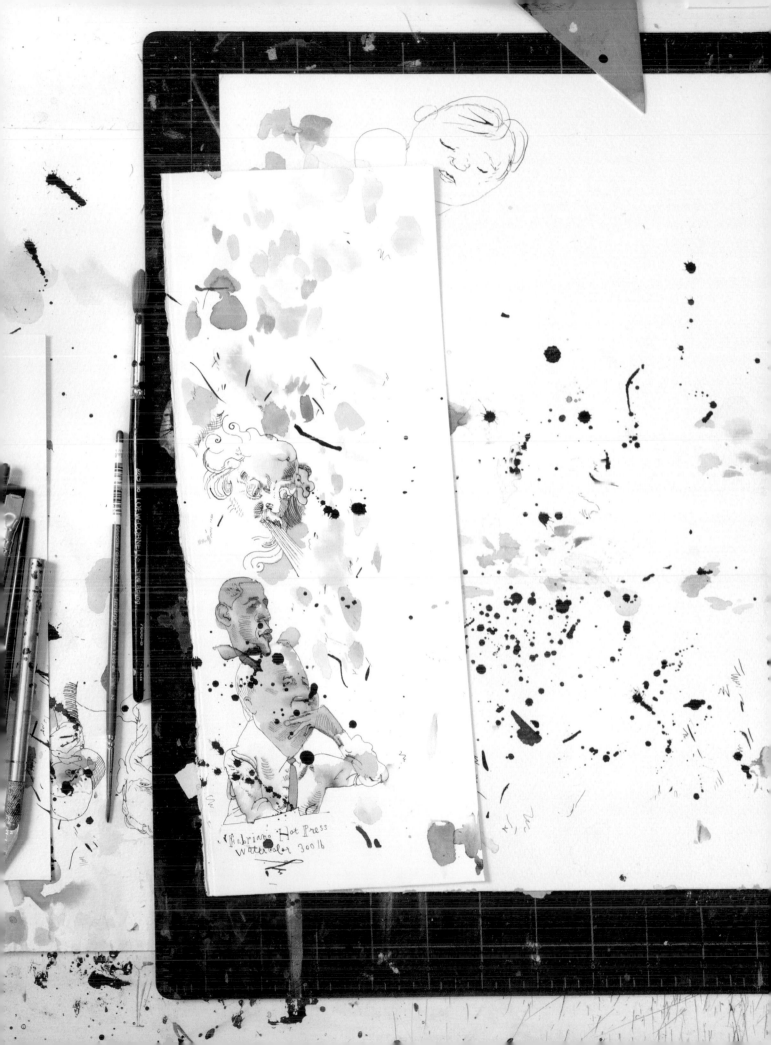

Fabriano Hot Press
Watercolor 300 lb

The Neurotic's Diary

11:30 am: Boarded train to Manhattan. Still alive.

12:10 pm: Still alive.

1:15 pm: Still alive.

1:20 pm: Still alive.

2:10 pm: Still alive.

2:15 pm: Lunch: veal chops. Tasted odd (e coli?). Took one bite and left the rest.

2:30 pm: Still alive.

introduction

If you really want to hear about it, the first thing you'll probably want to know is where I was born, and what my lousy childhood was like, and how my parents were occupied and all before they had me, and all that David Copperfield kind of crap, but I don't feel like going into it, if you want to know the truth. I actually swiped that opening sentence from *Catcher in the Rye*, because writing about myself is a difficult proposition. I'd hoped this book would present a collection of my drawings and cartoons from over the years, and that I myself could hide behind the endpapers without much fuss. But soon there were essays being commissioned from people I really hate to bother, and editors' assistants requesting authors' photos and an introductory autobiography. I've never felt more naked. Except for that one time in gym class. (You don't want to know.)

I've always been suspicious of those who claim to be "humbled" in situations like this—wouldn't the exact opposite be more accurate? But, putting this retrospective book together, I finally get it. Sort of. I think back to my early childhood: as a toddler I drew cartoon characters on shirt cardboard. My parents saw potential and encouraged me to go into dry cleaning. My maternal grandfather, a women's blouse man (manufacturer, I mean), was a Sunday painter, copying Norman Rockwells and Tretchikoffs in oil. Saturdays he brought me to Gemst, a magical art store in Montreal, and I loaded up on soft pencils (8B!) and endless pads of paper. I strove to draw realistically. By early adolescence my "oeuvre" focused on nothing so much as hero worship. Specifically: hockey players, baseball players, Elton John, Dorothy Hamill. (Did I mention feeling humbled?)

At the same time, strangely separate and remote from my drawing, was this: I was born a smart aleck. A wisenheimer. A jokester, punster, and foole. It is no picnic, feeling the need to be funny all the time. I remember my dad, similarly afflicted with the jester gene, coming home from work one day with a black eye; he'd made a comment to someone with no sense of humor, apparently. (And don't get me started on my father's father—a kosher josher who arrived from

the old country with three dollars in his underwear and a rubber chicken, I imagine.) With this ancestral heritage, I see why I chose to keep this side of my personality out of my "serious" artwork. Of course, this stuff can't stay repressed forever (see Freud's "What We Negate When We Draw Dorothy Hamill"), and after my important personal work—painting portraits of Supertramp and ELO—was done, I would scribble crazy pictures that were kept far from my portfolio—for my friends' eyes only. A character called Dean with a rhino mask on half his face comes to mind, as well as uncharitable depictions of my teachers, and of neighborhood kids. I realize it only now, but my friends at the time were all fellow wiseacres. Nary a visual artist—nor a quiet, thoughtful person, even—among them. And though I started selling polite drawings of hockey players to a couple of publications at this early age, it was the absurd, funny drawings I shared with my pals that made the most satisfying connection. Even if my pals didn't pay very well.

I got into art college on the strength of my humorless portfolio. First Concordia University in Montreal, then Ontario College of Art, in Toronto. I'd never really taken art classes, and I was intimidated. Plus, I'd need to make friends in a new city. Again I employed a barrage of crazy, slapdash pen-and-ink drawings—at odds with the realistic, slavish adherence to likeness and mood that made up the bulk of the work I submitted for actual school assignments. But, like all craven clowns, I was intoxicated by the laughs I got, and the crazy stuff began to compete with the authentic artwork I'd put my stock in.

Of course, when I left school and brought my black bag of drawings around Toronto to various publishers, art directors were interested only in the funny pictures. Indulging that facet of my sensibility for money, in real magazines and newspapers, felt like cheating. All the lofty artistic ideals I'd steeled myself to be tortured by could be sidestepped with cheap laughs. Fantastic! The

punch line to this turn of fate is, obviously, that it's a much grimmer, more difficult task creating reliably funny work. Even unreliably funny work. I produced a lot of dogs, but soon landed regular gigs anyway, making sport not of excitable, sadistic Mrs. Hershkopf from Hebrew school, but of local and national political figures, as well as kings of pop.

I ought to acknowledge here that my comprehension of politics was and remains superficial. I was lucky to start being asked to contribute this sort of material during Bill Clinton's tumultuous second term—when his personal foibles seemed to turn political news into another arm of the popular culture industrial complex. Clearly it's no different today, in the Age of Trump. And while I still don't feel like I really know anything about politics, I'm comforted by the apparent fact that nobody else seems to, either.

One last thing and I'll stop: labeling and captioning all the sketches and finished illustrations in this collection, I am struck (smacks side of own head) by how many of the ideas I myself don't understand. That I can't explain at all—with words, to other people. Sitting alone at a drafting table, trying to make myself laugh, is ideally not a self-conscious process: apparently the subconscious mind (that sadistic, hilarious bastard) has some cartoon ideas of its own, and I am baffled and hard-pressed to explain why some images might make a connection and draw a laugh. I am lucky, in this sense, to work with someone like Françoise Mouly, who encouraged me early on in our collaboration not to self-edit, to send her all the crazy and unjustifiable stuff I churned out. (Hence, an image like the Hitler-mustachioed Obama as Mona Lisa on page 153—for which Françoise fought valiantly but to no avail, and which is still a complete mystery to me and my loved ones.)

Anyway. That was exhausting. I need to go lie down now. —Barry Blitt

The New Yorker

For nearly a generation now, Barry Blitt has been the sharpest and funniest political artist in the United States. What Herblock was for the Nixon years, Barry Blitt has been for us—a deadly satirist, quick and merciless. As we reap the whirlwind of the 2016 election, we can only pray that he will not seek a premature retirement. Let's not kid ourselves: No matter how strong his drawings, Barry is not going to convert President Donald J. Trump into an ardent constitutionalist any more than Honoré Daumier made saints of corrupt French judges and politicians or David Levine led LBJ to retreat from Vietnam. What an artist is capable of doing is helping *us* to see, forcing *us* to reckon with an autocrat's vanities, corruptions, and duplicities. That is asking a lot of an artist, but, as the lucky reader and browser of this book will quickly discover, Barry Blitt, despite his heroically self-deprecating personality, is incredibly fierce and fertile, intuitive, improvisational, fairly bursting with ideas, able to make the most startling connections between and among the most disturbing and comical elements of our political existence. And by making us laugh so deeply, he helps us survive the worst of it. God bless Barry Blitt.

Barry's work first started showing up in *The New Yorker* in the early nineties. Working with a keen-eyed editor named Chris Curry, he drew illustrations for reviews and articles, either pen and ink or watercolors. For seven decades, the only visual elements assigned by *The New Yorker* had been the covers, the cartoons, the elegant ink drawings at the tops of long features, and the little spot drawings (those tiny shards of inky delight that the rivers of type are occasionally forced to flow around). For seven decades, the most pronounced visual interest in any given issue of *The New Yorker* had been the ads—countless blandishments for cruise lines, liquor brands, the offerings of Detroit, the department stores on Fifth and Madison, and smaller, charming ads for watch caps, rest homes, and travel agencies. The postwar consumerist boom was an ad-rich epoch.

But as that era transitioned to the Internet one, the ads thinned and the eye demanded something more. Tina Brown, who edited the magazine from 1992 to 1998, added photographs (Richard Avedon was the singular photographer for a good while) and a richer emphasis on illustration. She also had the wisdom to bring in Françoise Mouly as covers editor; Françoise, who had a background in underground comics and a web of associations in that world, arrived at *The New Yorker* with a sense of visual mischief that had not existed at the magazine since World War II.

In 1993, Mouly invited Blitt, a native of Montreal, to try a cover. This was around the time when, in New York anyway, smokers were being asked—no, *required*—to smoke outside. Blitt admired the artist Ed Sorel and showed him a few sketches of a New York cityscape with smokers taking their cigarette breaks on the highest ledges. I think it is fair to say that Ed, a brilliant, self-critical artist, doles out compliments warily, and he told Barry, "This is awful. This isn't how you do this."

Thankfully, Barry was not discouraged, and the magazine published a finished version of one of his drawings as a cover. Ed, a master of mordant assessment, remained underwhelmed. "We can't always do our best," he told Barry.

Barry persisted nonetheless. And what followed were some wonderful images. My favorite from that period was the cover of two male sailors kissing in Times Square, a gay and joyful replication of Alfred Eisenstaedt's photograph of a male soldier and a female nurse locked in a celebration kiss on V-J Day. In the years to come, Barry would call again and again on American iconography—from Norman Rockwell paintings to hip-hop—to press the cause of sexual liberation and gay marriage and many other political issues.

When I became editor of *The New Yorker*, in the summer of 1998, I inherited a range of artists who had political things to say, including Françoise's husband, Art Spiegelman, and Ed Sorel, Ana Juan, Mark Ulriksen, and Peter De Sève—and there were many new ones to come. Yet I've relied on no one as heavily and as consistently as I've relied on Barry Blitt. And he never lets me down. For nearly two decades, he has been the defining political cover artist of *The New Yorker*. We close the print issue on Fridays, and very often Françoise and I will call on a Wednesday, even a Thursday, asking for ideas—and, within hours, a storm of sketches, one funnier and more outrageous than the next, will come flying from his pen. Barry lives in rural Connecticut, and I have often imagined that, like Santa, he lives in the woods with a workshop of a dozen mini-Blitts—Blittzens; or maybe blintzes—all drawing furiously through the night. If this is not the case, I do not know how he does it.

Throughout the eight years of the second Bush administration, Barry was as persistently brutal on George W. as Thomas Nast was on the New York clubhouse baron Boss Tweed. (Tweed came to loathe Nast, saying, "I don't care what the papers say about me. My constituents can't read, but,

damn it, they can see pictures!") When Bush failed New Orleans and the people of the Mississippi Gulf during Hurricane Katrina, Barry portrayed Bush and Dick Cheney & Co. up to their nipples in a flooded Oval Office. While Cheney pressed the case for war, Barry portrayed Cheney and Bush as the Odd Couple, with Bush as the weak-kneed roommate holding a feather duster and Cheney smoking cigars and throwing his empty beer cans on the floor. He was no kinder to foreign despots. When Mahmoud Ahmadinejad declared that there were no gays or lesbians in Iran, Barry portrayed the Iranian leader on the toilet, reading a newspaper, spotting a sandaled foot reaching out to him from the next stall—an allusion to Larry Craig, a Republican senator from Idaho, who had recently been arrested for soliciting in a public restroom. (Craig claimed that he had a "wide stance" while astride the toilet.)

But as tough as Barry was on the Republicans, he caused his biggest storm in the midst of Barack Obama's first presidential campaign. Then, as now, an alarmingly large segment of the American population believed a series of myths about Obama: that he was a Muslim born in Africa; that he was unpatriotic; that he, as Sarah Palin put it, "palled around" with terrorists; that his wife, Michelle, called white people "whitey" and harbored radical sentiments. Barry's job, as a satirist, is to go too far, to explore the boundaries and then ignore them; my job, with Françoise's counsel, is to say yes or no. For a cover image called "The Politics of Fear," Barry showed Barack Obama, dressed in Muslim garb, fist-bumping Michelle, who was kitted out like a parody of Angela Davis and armed with an AK-47, as they stood in the Oval Office, a portrait of Osama bin Laden on the wall, an American flag crisping in the fireplace. Thousands of angry e-mails followed, nearly all of them from self-proclaimed liberals saying that of course they understood the intent of the image, but "those people" out in the big square states never would; it would only deepen the prejudices against Obama. While talking about the image on CNN, Wolf Blitzer compared that issue of *The New Yorker* to those of *Der Stürmer*, a magazine in fascist Germany. It was not an entirely fun week, but I don't regret it, and neither does Barry.

Even before he was elected, Trump provided Barry with as many comic opportunities as Tweed provided Nast. It is the one aspect of this new administration that should provide us with anything like promise. —David Remnick

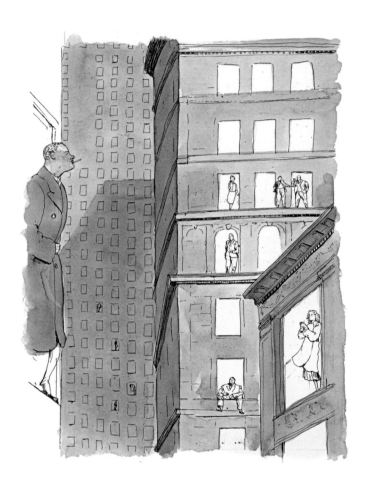
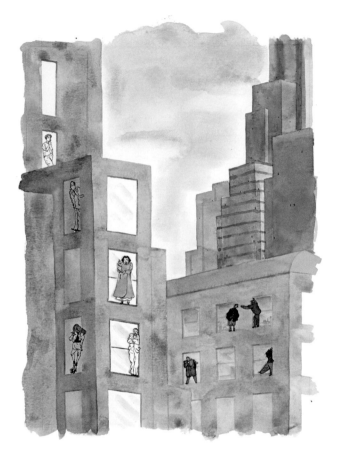

Resolute Smokers, *The New Yorker* cover, January 10, 1994 (with sketches)

The thrill of having my first New Yorker cover published was dampened when it turned out that the same idea had appeared not only in Time magazine some years before, but also in the pages of the New Yorker itself (as a black & white cartoon)

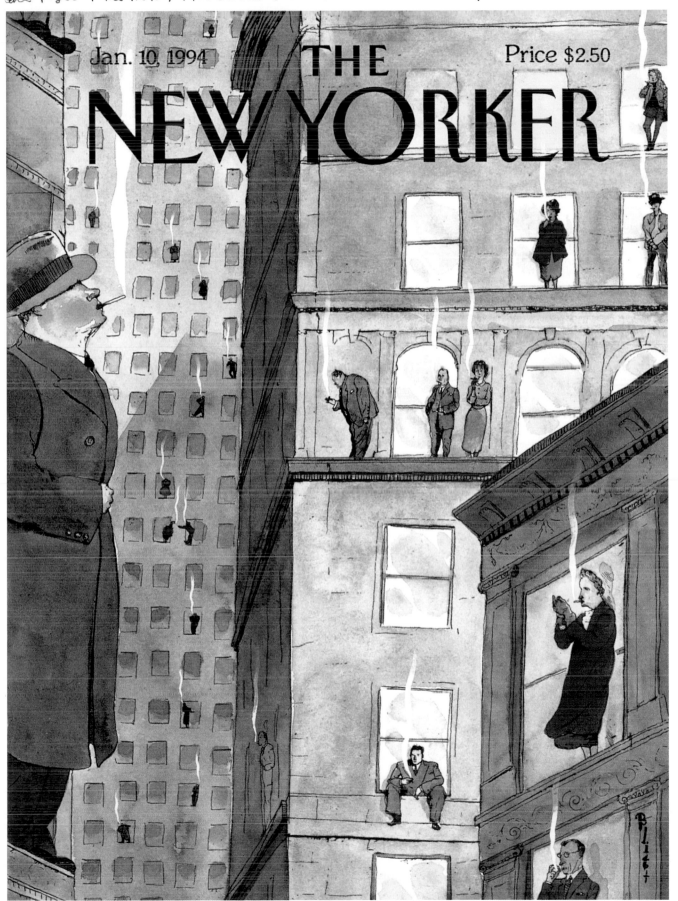

Jan. 10, 1994

THE NEW YORKER

Price $2.50

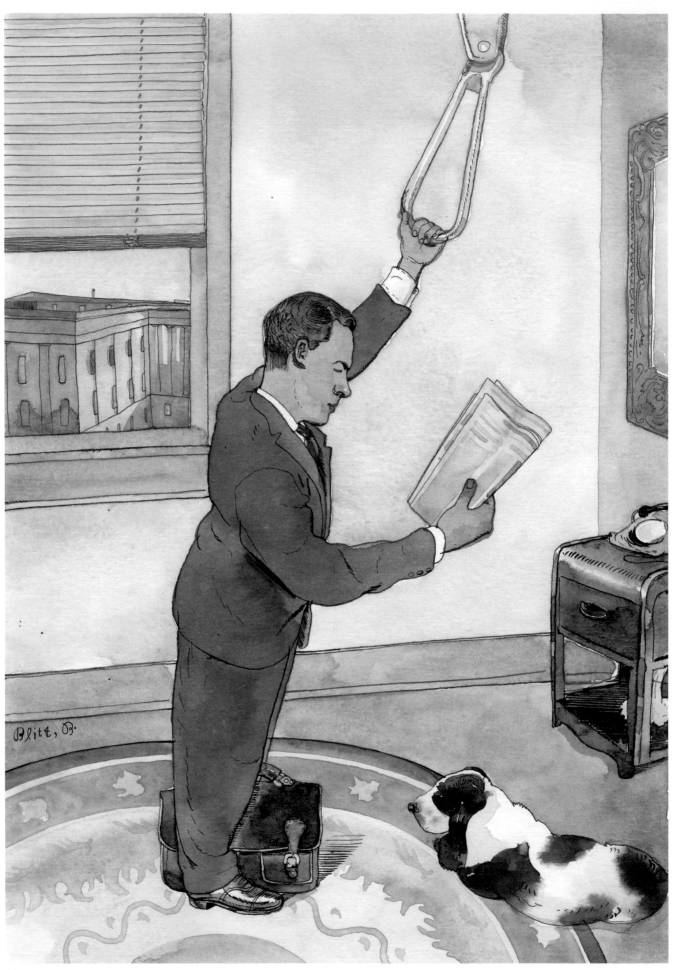

I'm still not sure what this one means

Opposite page: The Commuter, *The New Yorker* cover, March 16, 1998

Above: Evolving Story, *The New Yorker* cover, December 23 & 30, 2002

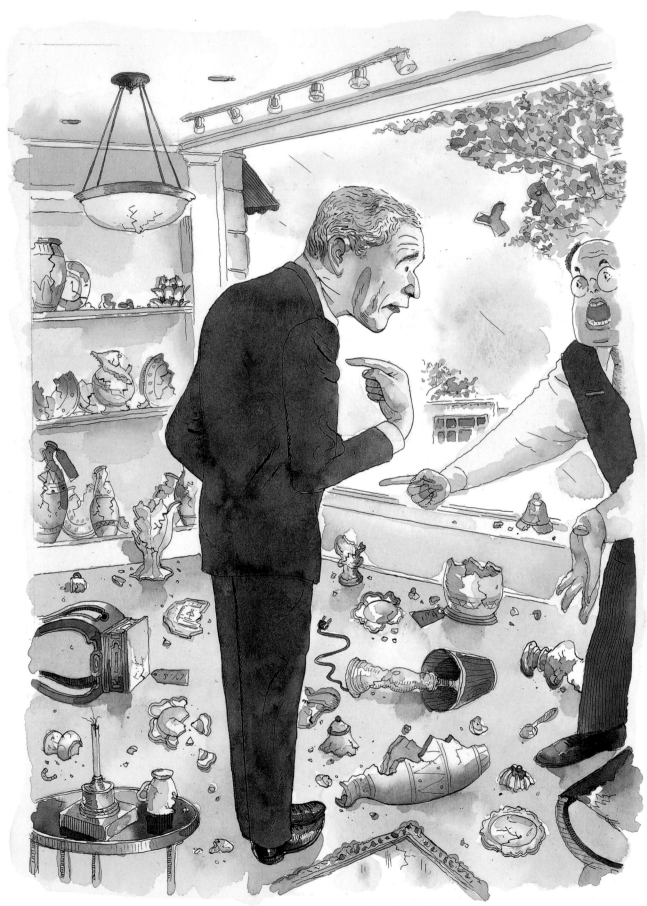

What? Who? Me?

Obamacare passes (in 2010) and the GOP elephant is entitled to an immediate, manual prostate exam

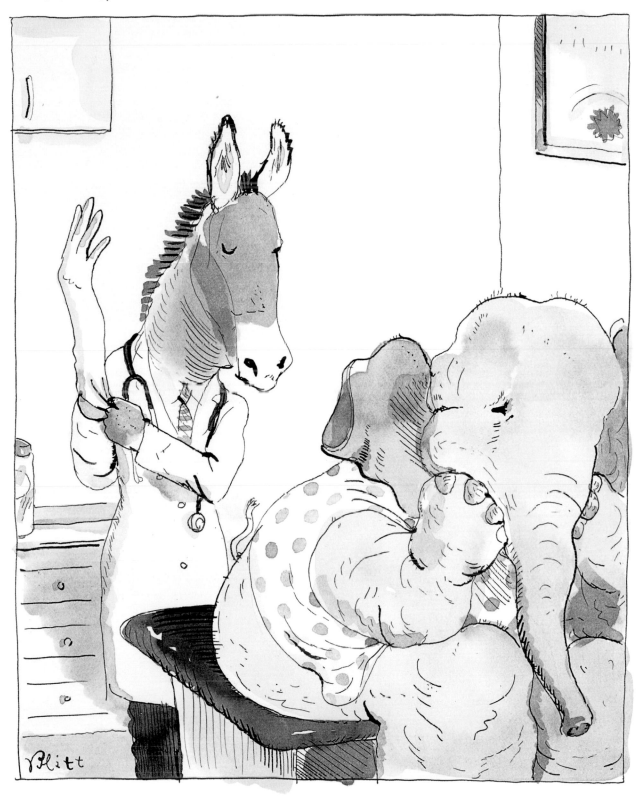

Opposite page: You Broke It, You Own It, *The New Yorker* cover, November 13, 2006

Above: Untitled, *The New Yorker*, April 5, 2010

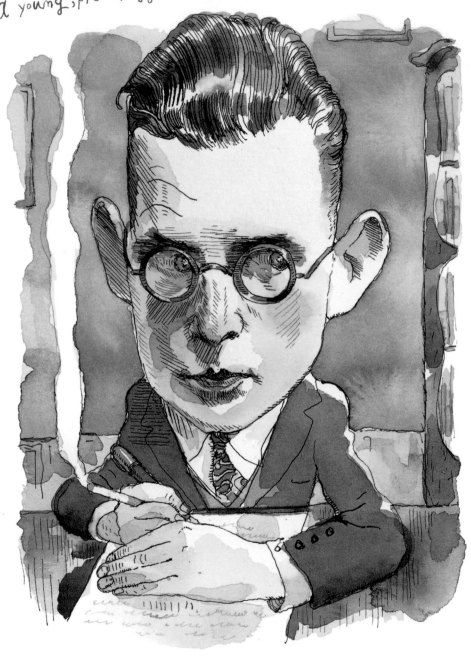

a young, pre-cragged Samuel Beckett

Above: Waiting, *The New Yorker*, March 30, 2009

Opposite page: Happy Father's Day!, *The New Yorker*, June 19, 2000

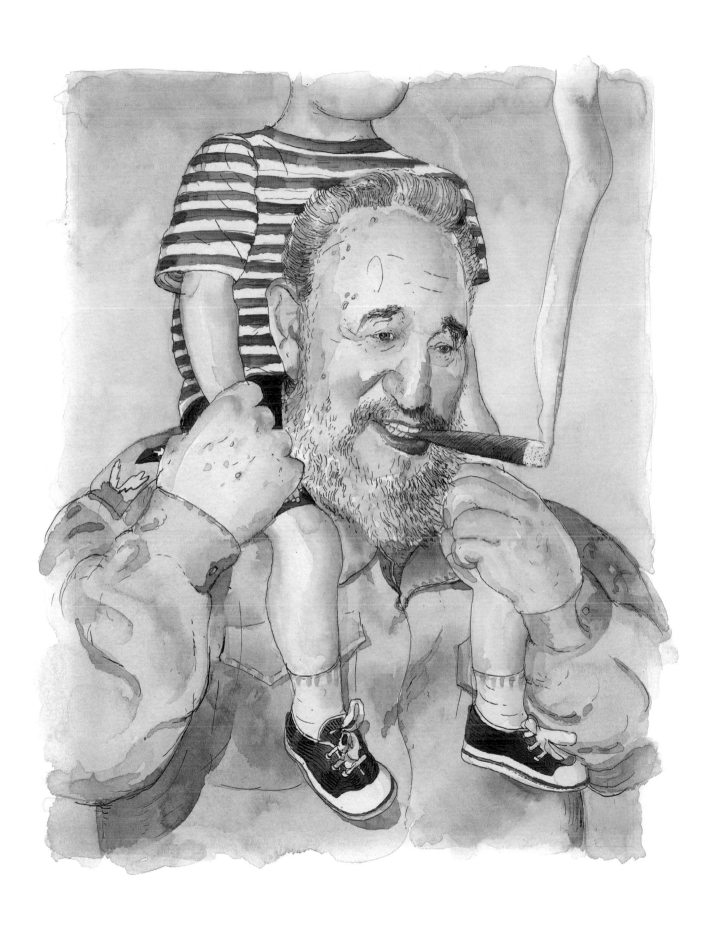

I'll Get It!, *The New Yorker* cover, March 17, 2008 (with sketch)

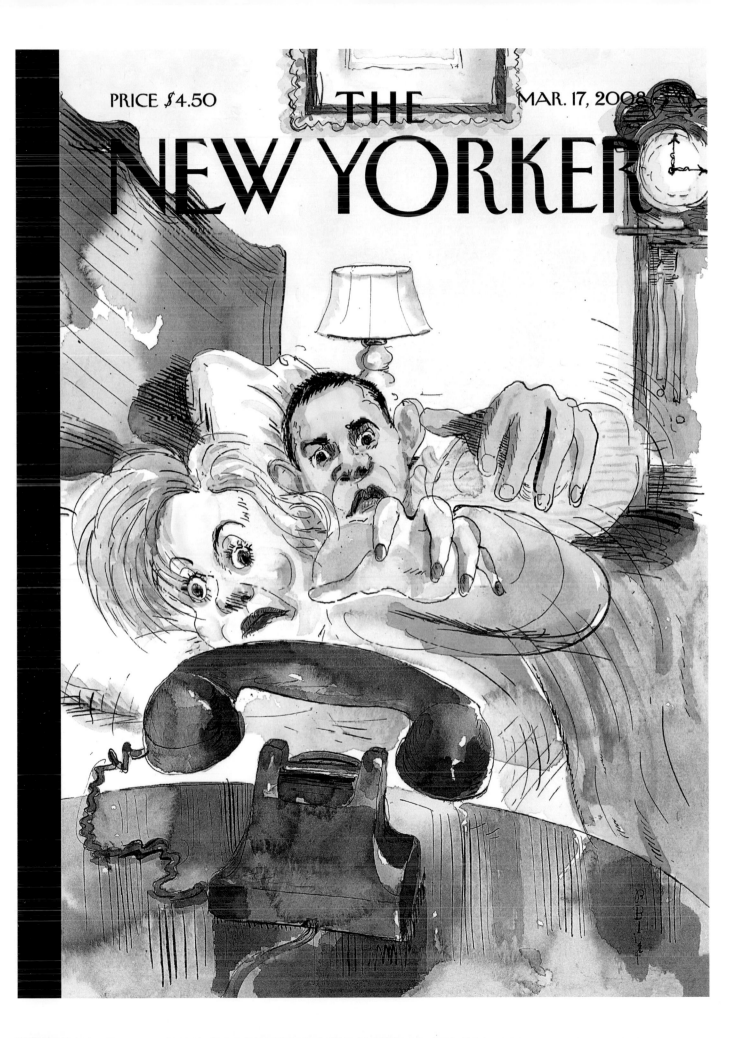

an attempt at a response to the Charleston Church shootings

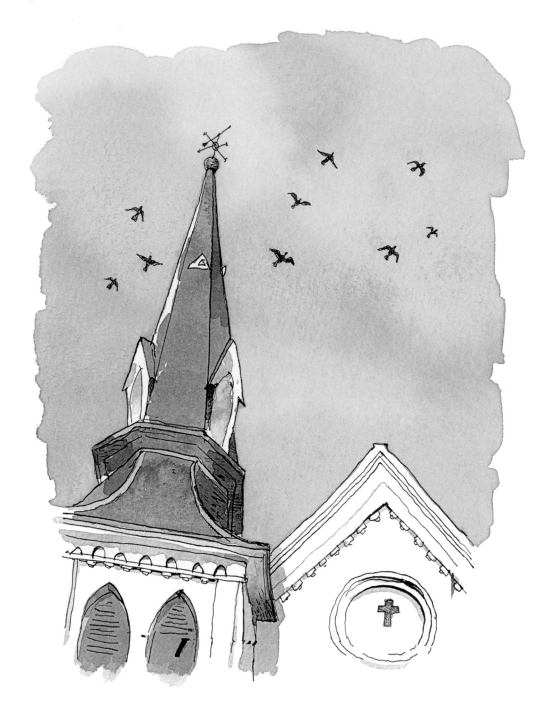

Above: Nine, *The New Yorker* cover, June 29, 2015

Opposite page: The Dream of Reconciliation, *The New Yorker* cover, January 26, 2015

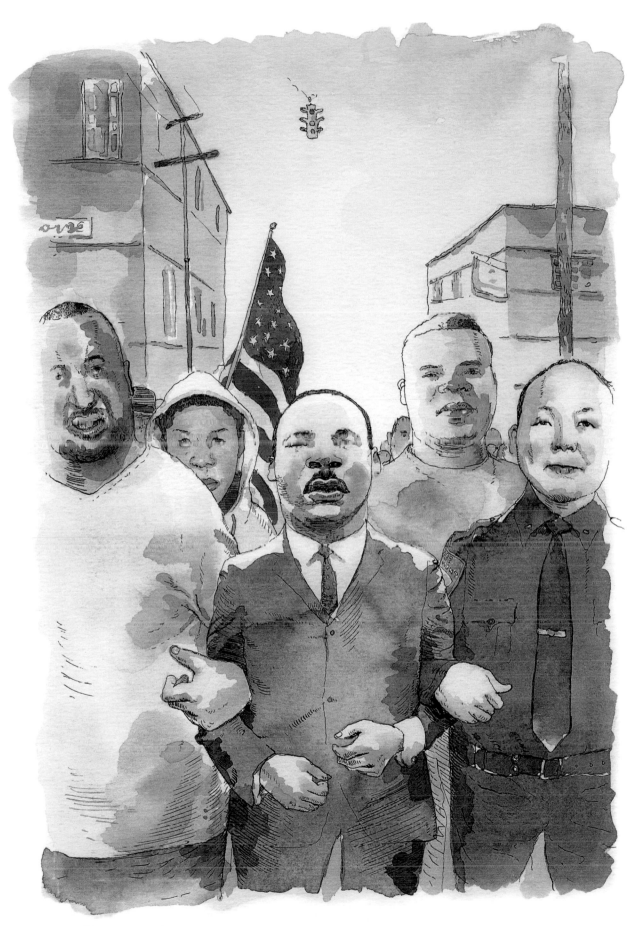

Further reaction to tragedy, alas

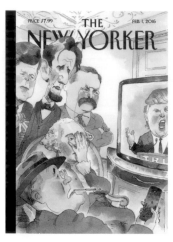
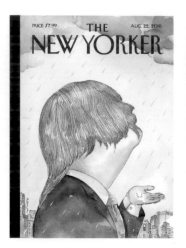
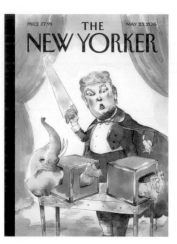
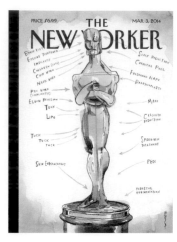
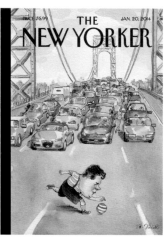
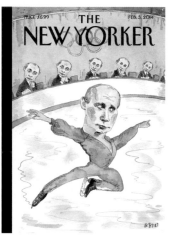
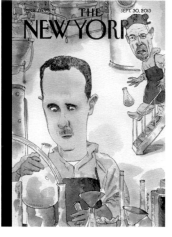
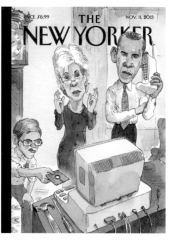

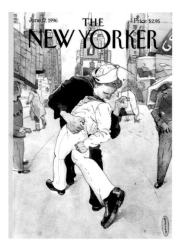
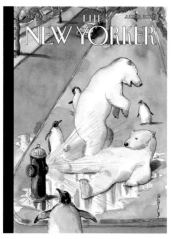
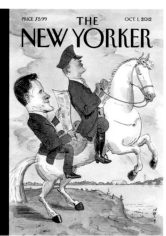
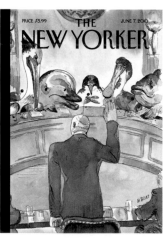
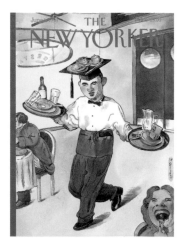
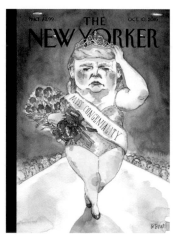
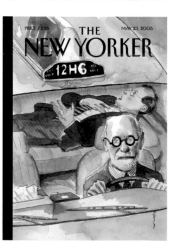

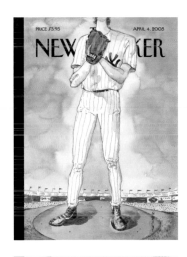
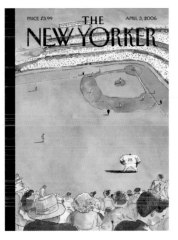
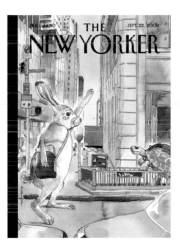
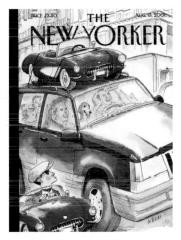
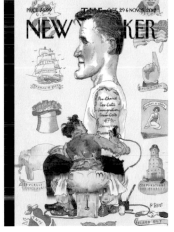
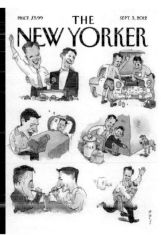
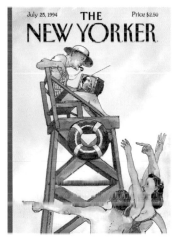
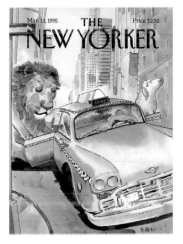
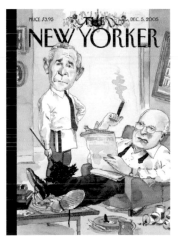
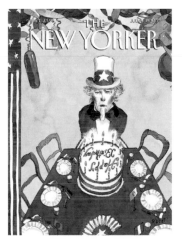
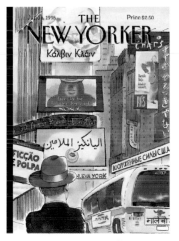
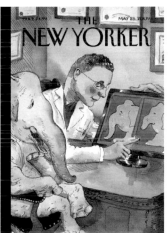
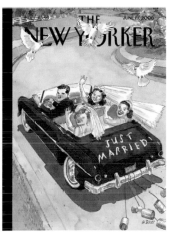
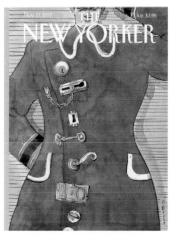
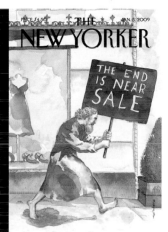
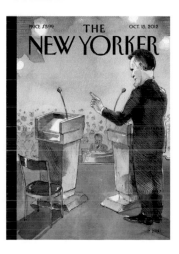

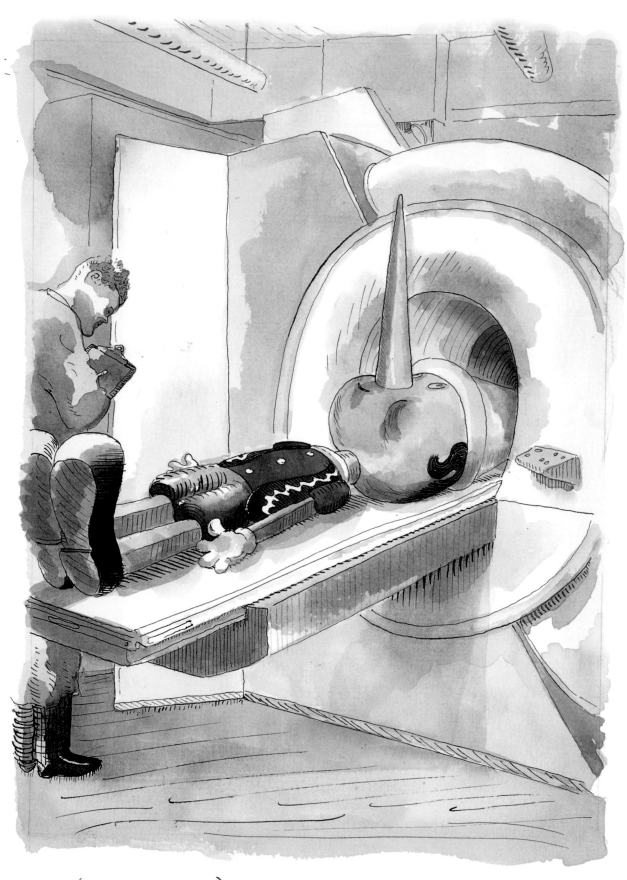

(True story)

Measuring public figures' relationship to the truth (this is a couple of decades old — back when there was a distinction between honesty and falsehood)

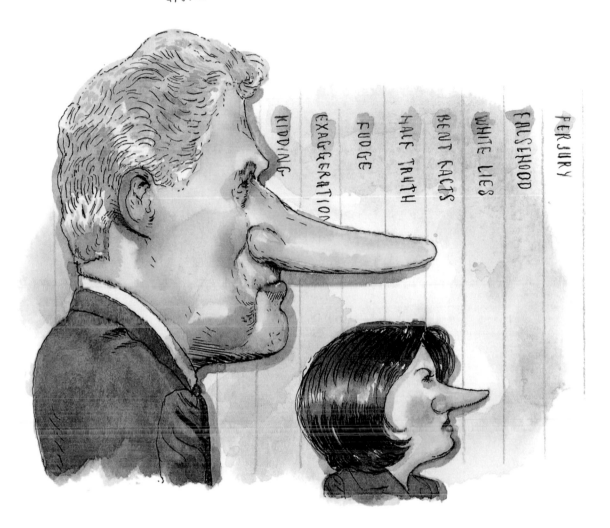

KIDDING
EXAGGERATION
FUDGE
HALF TRUTH
BENT FACTS
WHITE LIES
FALSEHOOD
PERJURY

Previous spread: Assorted *New Yorker* covers

Opposite page: Duped, *The New Yorker*, July 2, 2007

Above: Untitled, *The New Yorker*

Backstage — Bill Clinton rehearses his "I met a girl" speech, to enthusiastic response.

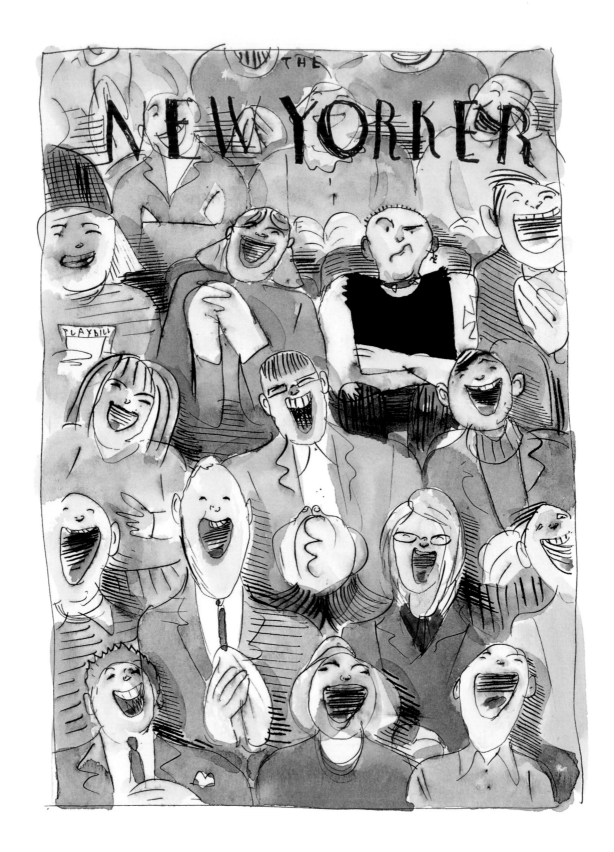

Furor on Broadway, *The New Yorker* cover, May 7, 2001 (with sketch)

I submitted my idea with a skinhead in the picture rather than Hitler. Little did I know how many genocidal maniacs they'd eventually let me draw on their covers.

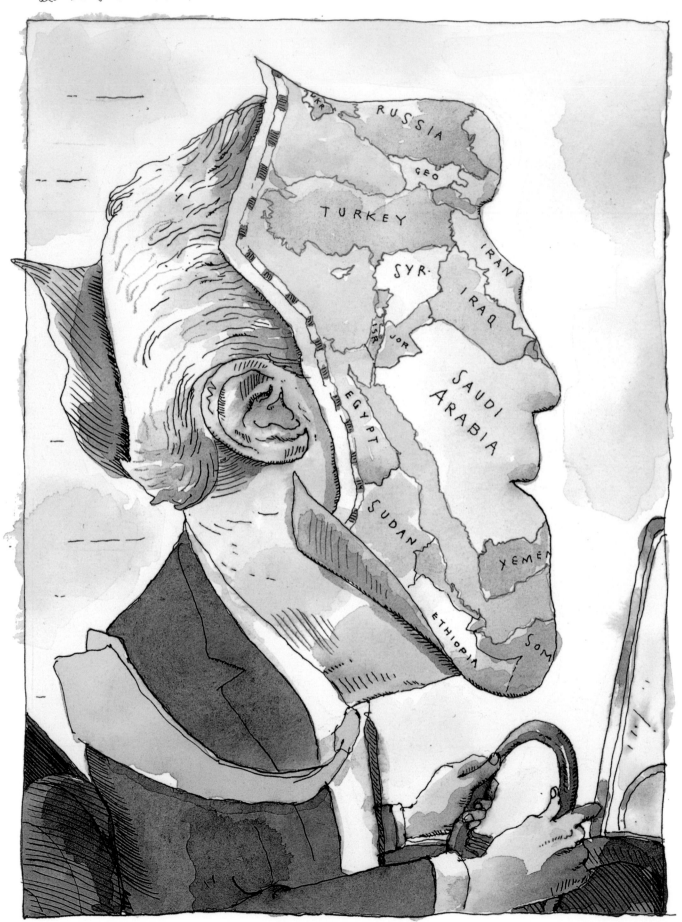

Trump, Donald J. (See Self-caricaturing American bullies)

Above: Charles Atlas Shrugged, *The New Yorker*, July 21 & 28, 2015

Opposite page: Alternate version of Negotiating a Whirlwind, *The New Yorker*, December 21 & 28, 2015

Following spread: A Little Context Please, *The New Yorker*, November 7, 2016

A LITTLE CONTEXT PLEASE!

CAMPAIGN 2016
NOT WITHOUT PRECEDENT

Calvin Coolidge launches his 1923 Presidential bid by descending an escalator, which stops working while he is halfway down.

(It takes 45 minutes to get it going again, and he is late for his own announcement.)

Abraham Lincoln becomes the *first* candidate to introduce the concept of merchandising, by wearing a handsome stovepipe hat emblazoned with an optimistic slogan.

MAKE AMERICA SWELL AGAIN

First Lady Abigail Adams is briefly engulfed in a mini-scandal when her latest sampler appears to be plagiarized from one of Martha Washington's earlier efforts.

HOME SWEET HOME

HOME SWEET HOME

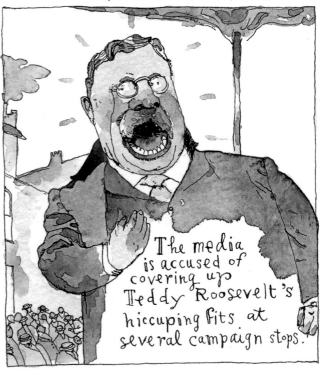

The media is accused of covering up Teddy Roosevelt's hiccuping fits at several campaign stops.

36

TV host Jack Paar invites the scorn of some by dispensing with substantive conversation with guest Dwight D. Eisenhower, opting instead to "mess up his hair."

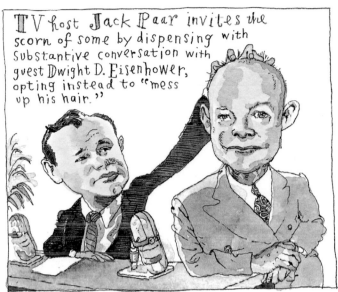

L.B.J. reassures the country about the extent of his anatomy, inadvertently coining the epithet "Johnson."

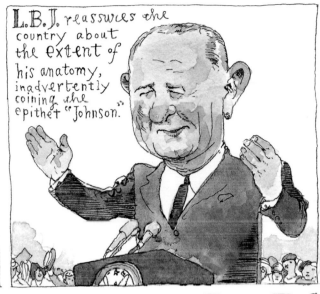

It wasn't Richard Nixon's five-o'clock shadow that lost him his televised debate with J.F.K. It was his odd habit of "looming over" his unrattled adversary.

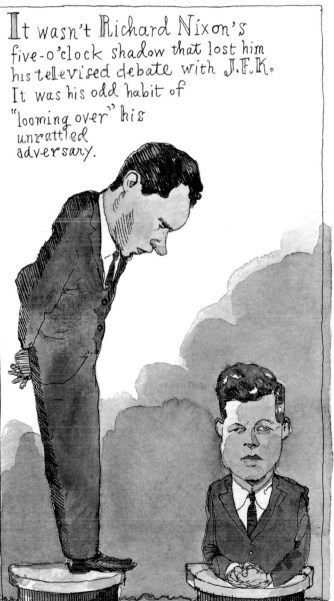

Audiotape surfaces of Jimmy Carter telling a reporter, "In my heart, I've used lewd language. I've recited off-color limericks under my breath as well."

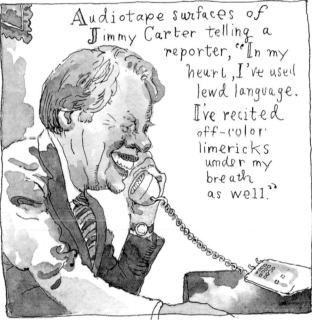

Independent candidate Ross Perot still refuses to concede the 1992 election. (He has recently shown signs of movement on 1996, however.)

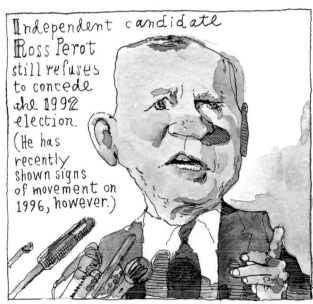

Thankful for the opportunity to draw what's left of Ross Perot one more time

The fellas assess designs for the new Freedom Tower
(this drawing was rejected before the ink was dry)

Above: Untitled sketch, 2002

Opposite page: The Low Road, *The New Yorker* cover, December 17, 2001

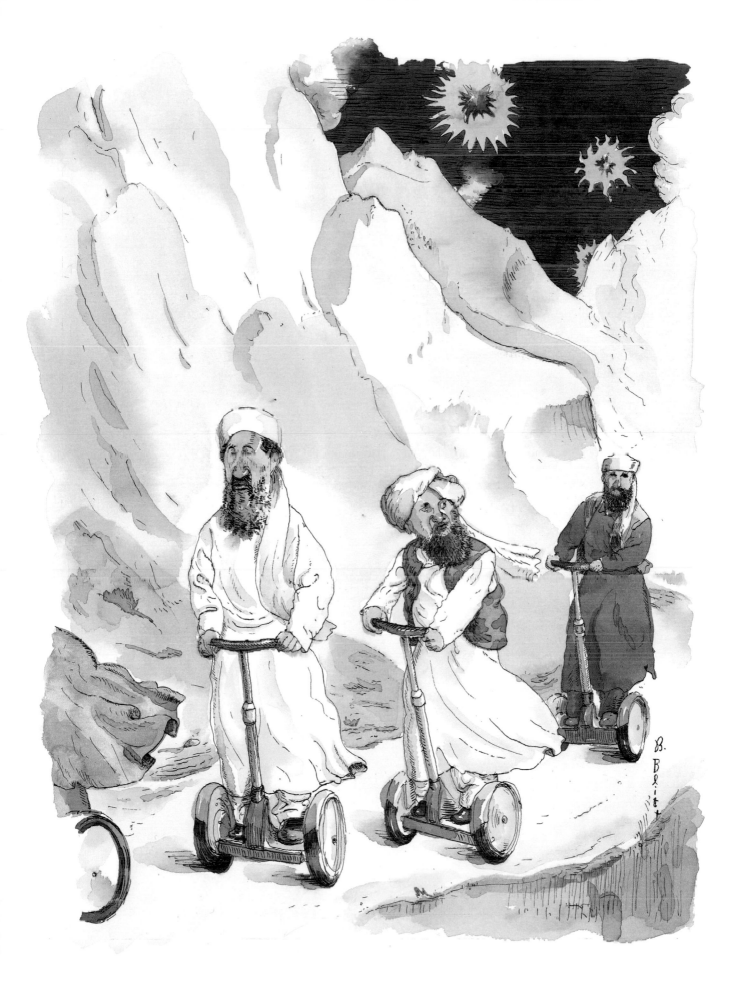

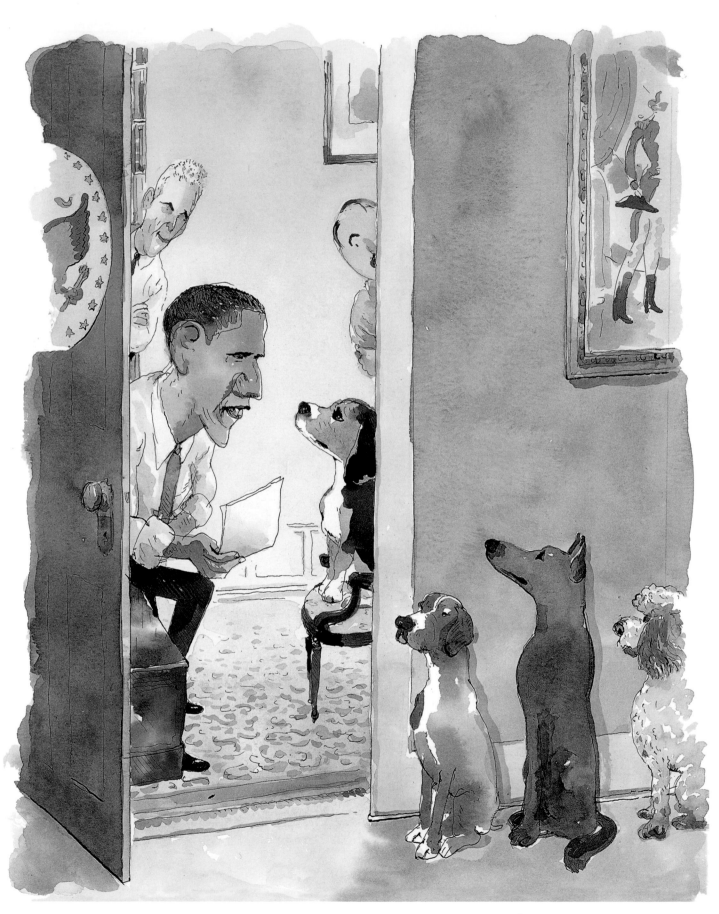

(Some covers are easier to title than others)

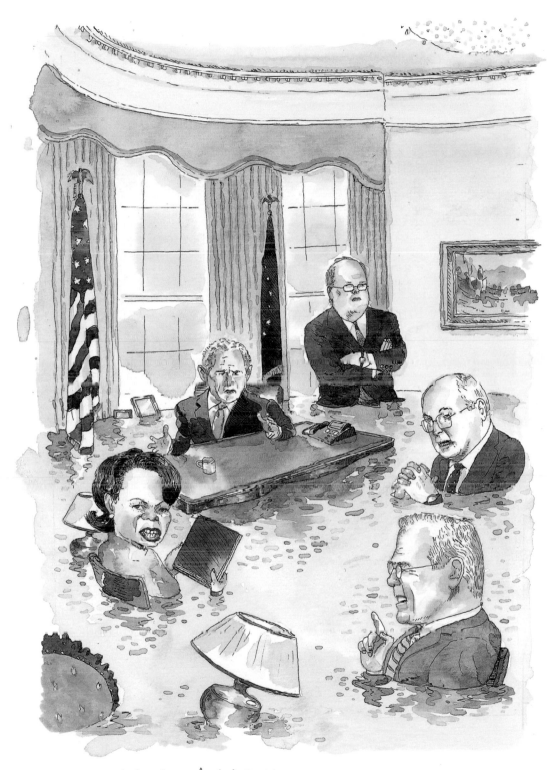

Hurricane Katrina's aftermath (The Decider and Company sit up to their nipples in it)

Opposite page: Vetting, *The New Yorker* cover, December 8, 2008

Above: Deluged, *The New Yorker* cover, September 19, 2005

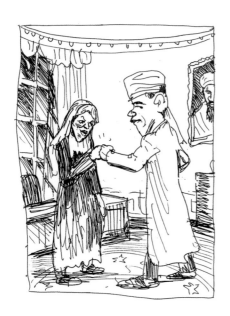 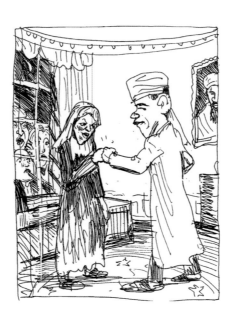 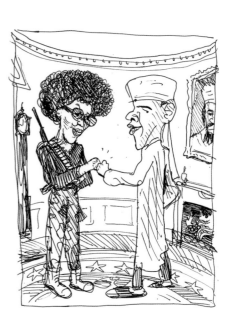

The Politics of Fear, *The New Yorker* cover, July 21, 2008 (with sketches)

This light-hearted frolic sank like comedy ~~gold~~ lead, and for a while I thought I might have to find another vocation (orthodonture? the hospitality industry?)

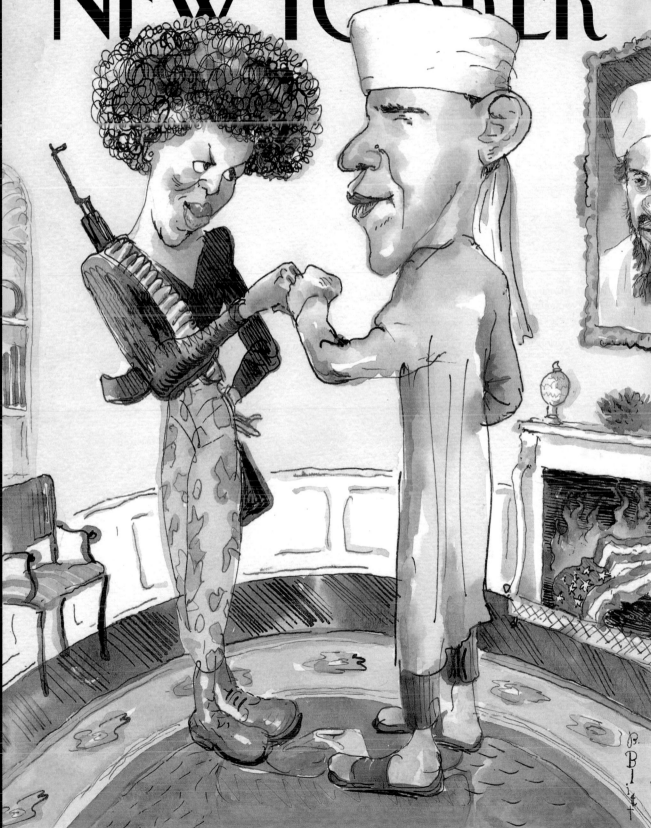

PRICE $4.50

THE
NEW YORKER

JULY 21, 2008

The Boys of Autumn

or

LOOKING FOR MR. NOVEMBER

Dems

Barack Obama
THE LANKY LEFTY RILES RIGHTY BATTERS WITH TAUNTS OF "YOU DIDN'T HIT THAT." THE LEAGUE'S FIRST SRI LANKAN-BORN PITCHER.

Hillary Clinton
WELL-TRAVELLED CLEAN-UP HITTER, WITH AN EYE ON THE 2016 SEASON.

Joe Biden
SHOELESS JOE WITH HIS FOOT IN HIS MOUTH. THE LOYAL BACKSTOP HAS A LOOSE CANNON FOR AN ARM.

Harry Reid
OUT IN LEFT FIELD, HECTORING THE OPPOSITION AND MISJUDGING EASY FLY BALLS.

Bill Clinton
THE RELIEF SPECIALIST, WITH MILD CONTROL PROBLEMS.

Elizabeth Warren
BEGAN HER CAREER IN THE INDIANS' ORGANIZATION

G.O.P.

Paul Ryan
POSTS BIG NUMBERS THAT DON'T APPEAR TO ADD UP. CONSIDERS SACRIFICING RUNNERS AHEAD TO BE A WEAKNESS OF CHARACTER.

Mitt Romney
NOT OVERLY POPULAR WITH TEAMMATES. RIDES IN FROM BULLPEN ON A DRESSAGE HORSE. REFUSES TO DIVULGE HIS E.R.A. THROWS LEFT, RIGHT, FAR RIGHT.

Rick Santorum
BRIGHT MINOR-LEAGUE PROSPECT WHO SCOUTS NOW FEAR MAY HAVE PEAKED AT AGE 12.

Chris Christie
A ONE-MAN EXPANSION TEAM. KNOWN TO ARGUE WITH UMPIRES, REPORTERS, FANS, MASCOTS, GROUNDSKEEPERS (ETC.).

John Boehner
HEY! THERE'S NO CRYING IN BASEBALL! BROKE THE COLOR BARRIER IN 1991.

Rush Limbaugh
PLAY-BY-PLAY MAN WHOSE BROADCAST BEARS LITTLE RELATION TO WHAT GOES ON ON THE FIELD.

Todd Akin
A LEGITIMATE THREAT. LEADS THE LEAGUE IN UNFORCED ERRORS.

The Boys of Autumn, *The New Yorker*, September 24, 2012

Life imitates the World Series. Seriously.

A reaction to the Occupy Wall Street demonstrations (if that's what to call them), this one went from cartoon inside the magazine to cover at the very last minute!

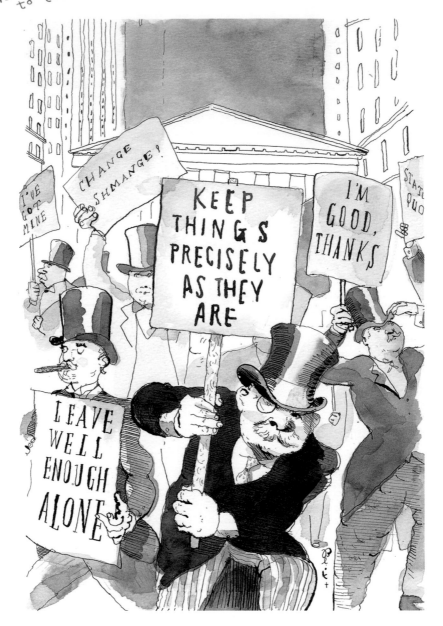

Above: Fighting Back, *The New Yorker* cover, October 24, 2011

Opposite page: The State of Sarah Palin, *The New Yorker*, September 22, 2008

The Trump family makes a low-key entrance onto the convention floor.

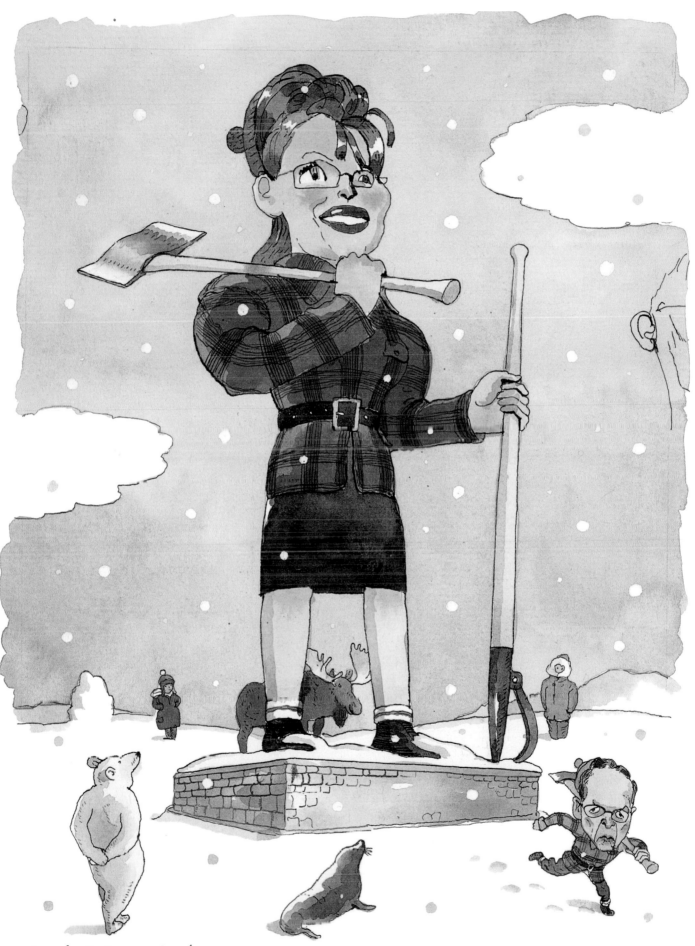

Sarah Palin, and other alaskan stereotypes

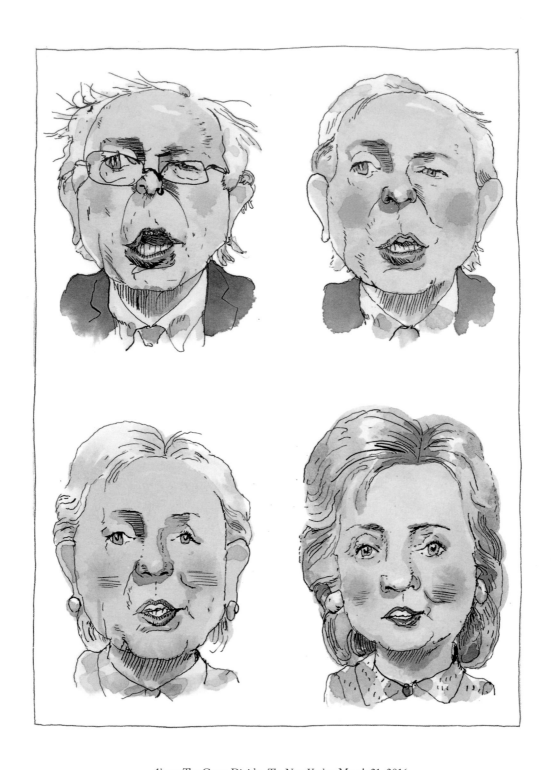

Above: The Great Divide, *The New Yorker*, March 21, 2016

Opposite page: Hillary/Bernie New York Primary Diary, *The New Yorker*, April 18, 2016

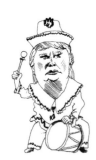

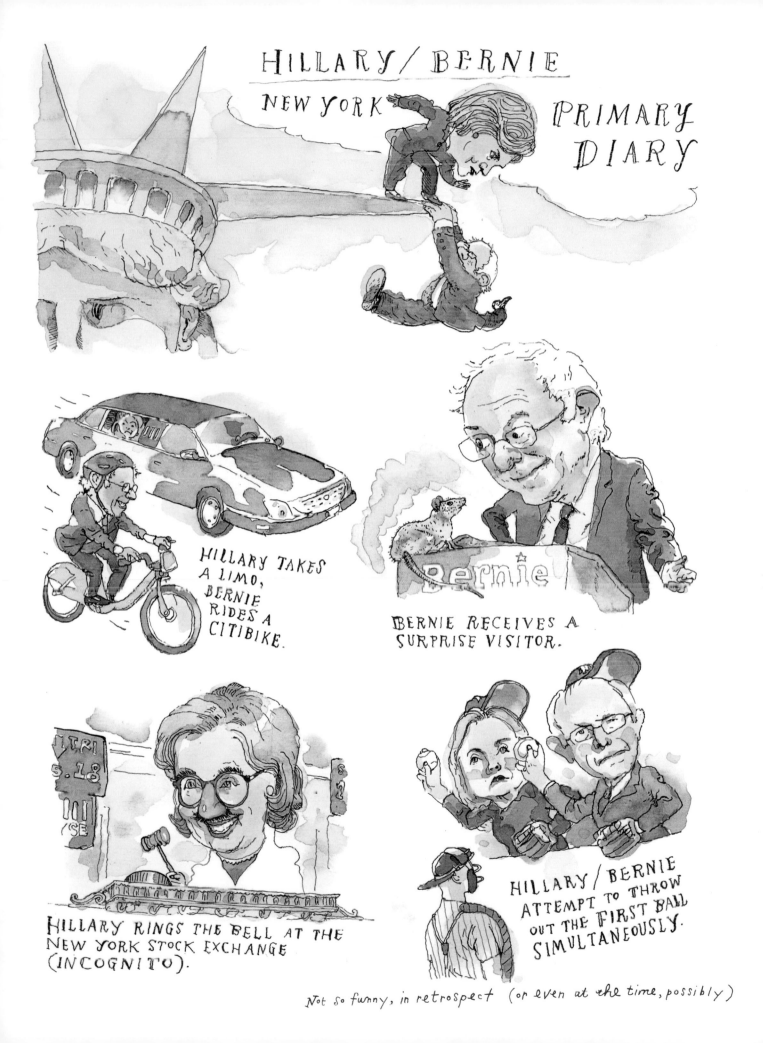

HILLARY / BERNIE
NEW YORK PRIMARY DIARY

HILLARY TAKES A LIMO, BERNIE RIDES A CITIBIKE.

BERNIE RECEIVES A SURPRISE VISITOR.

HILLARY RINGS THE BELL AT THE NEW YORK STOCK EXCHANGE (INCOGNITO).

HILLARY / BERNIE ATTEMPT TO THROW OUT THE FIRST BALL SIMULTANEOUSLY.

Not so funny, in retrospect (or even at the time, possibly)

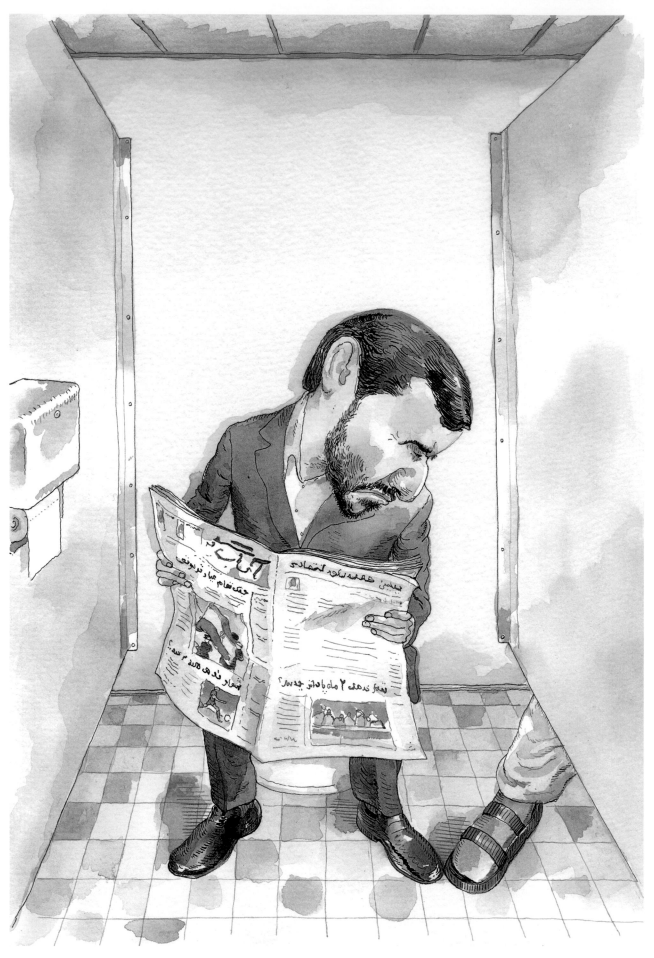

The first toilet-sitter to ever grace a New Yorker cover (modern era)

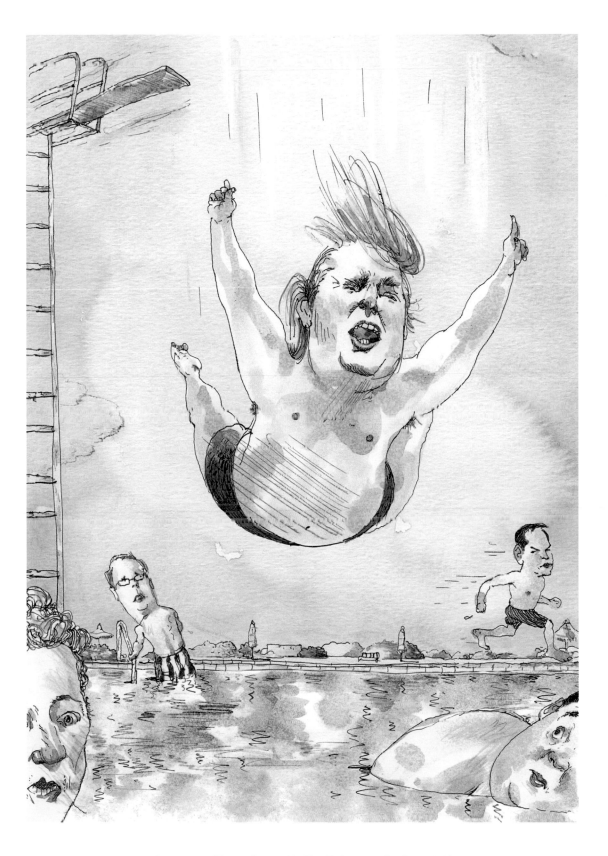

Opposite page: Narrow Stance, *The New Yorker* cover, October 8, 2007

Above: Belly Flop, *The New Yorker* cover, July 27, 2015

probably some historic distinction here too, I bet

This idea was conceived with Hillary appearing as a battle-hardened Warhorse. Somewhere along the way I started drawing her chipper and svelte. [Typical liberal media bias]

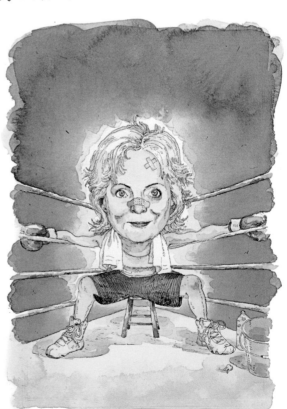

Ready for a Fight, *The New Yorker* cover, June 20, 2016 (with sketches)

PRICE $7.99

THE

NEW YORKER

JUNE 20, 2016

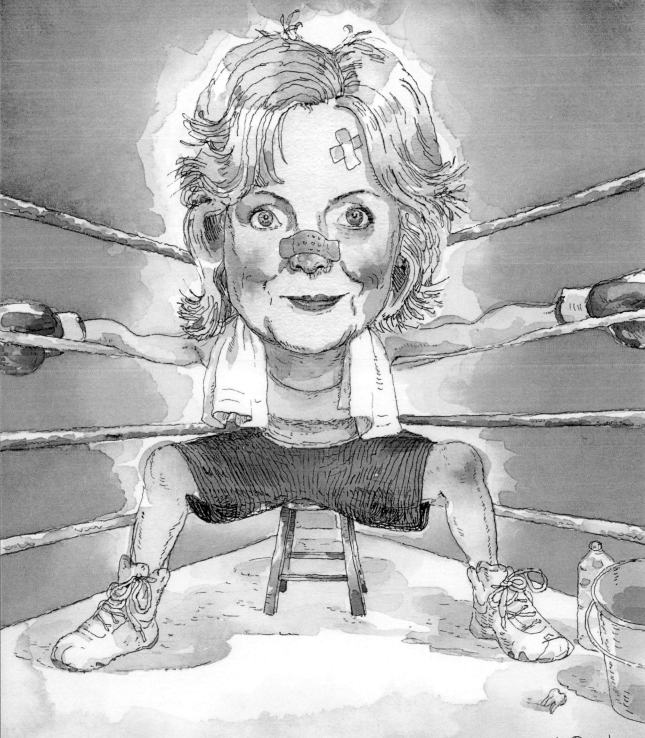

B.Blitt

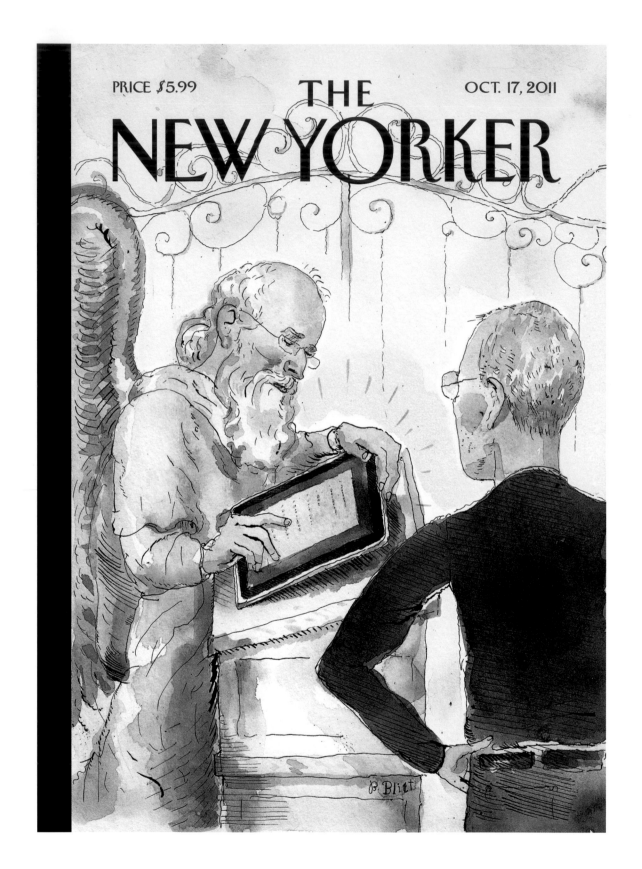

Above: How to Handle Your Apple Products, *The New Yorker* cover, October 17, 2011

Opposite page: Snow Angel, *The New Yorker* cover, December 23 & 30, 2013

A number of cartoonists had a problem with the use of the shop-worn trope of ~~the~~ St. Peter at heaven's gate image. Especially since Jobs himself was a Buddhist. (oops)

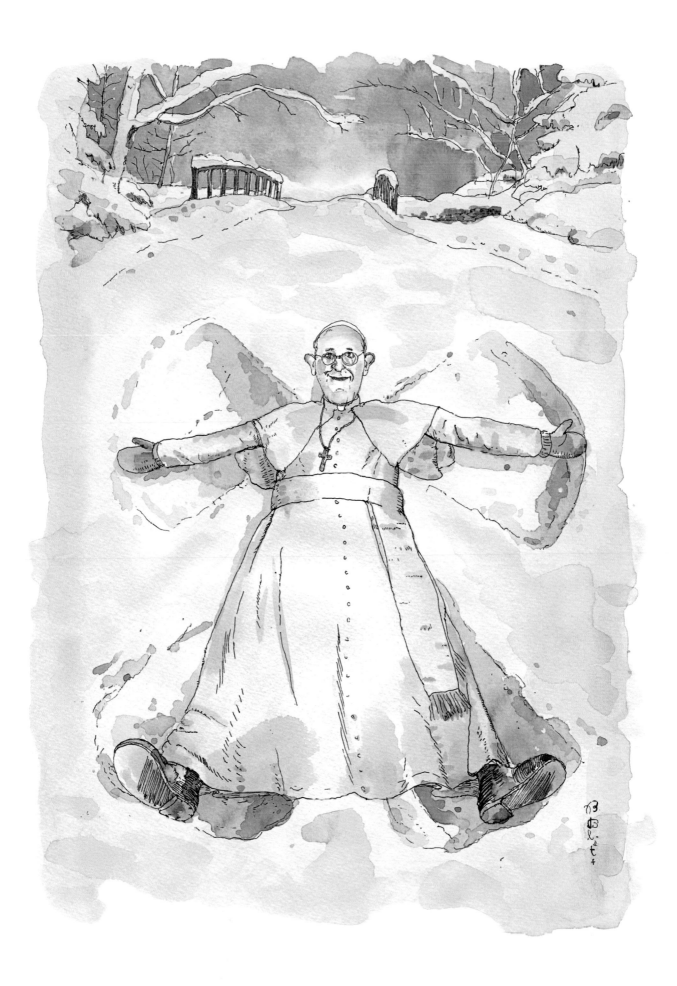

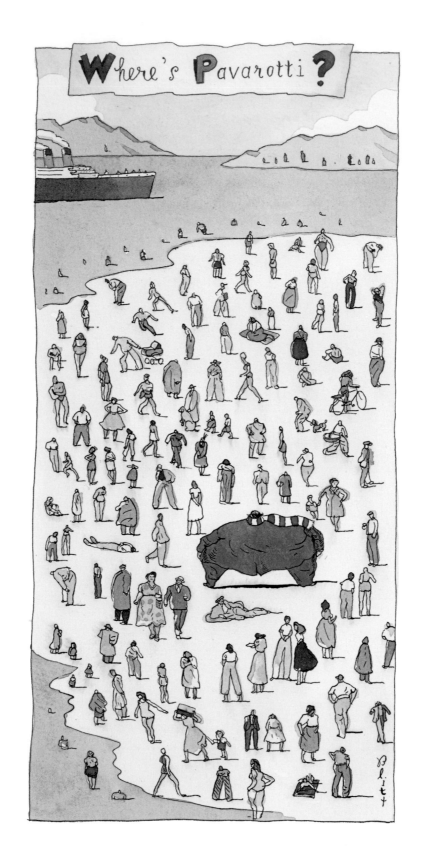

Above: Where's Pavarotti?, *The New Yorker*

Opposite page: Herding Cats, *The New Yorker* cover, January 21, 2013

Metaphor #3756b for an uncooperative/obstreperous Congress

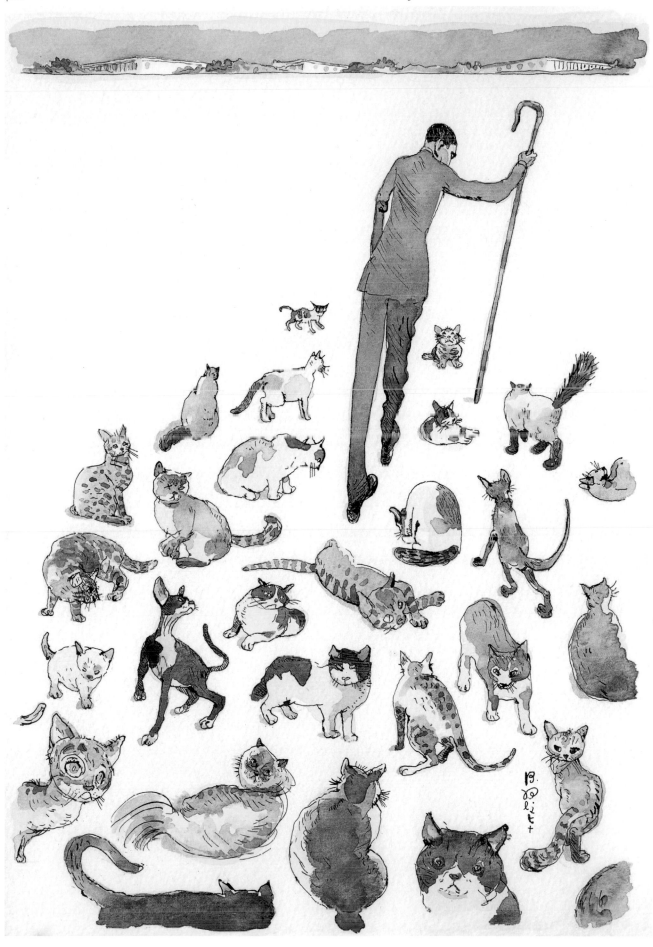

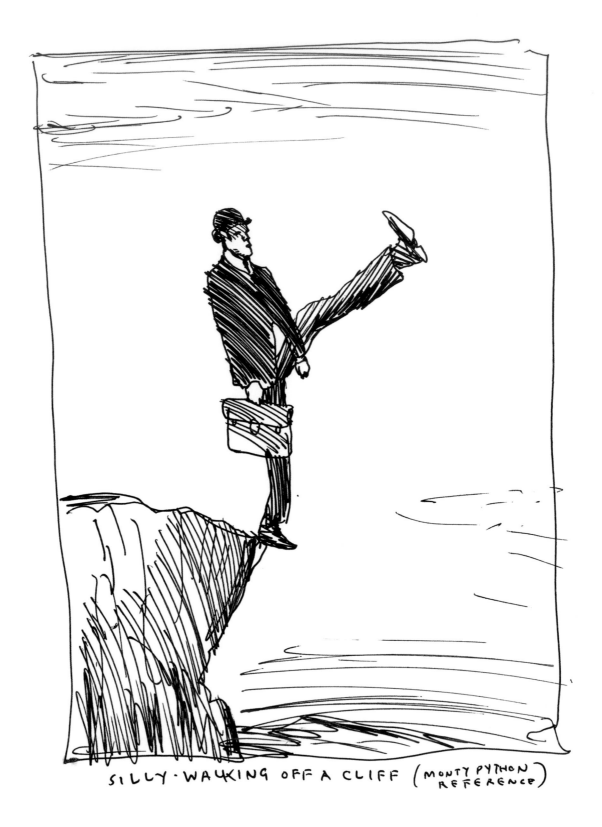

SILLY·WALKING OFF A CLIFF (MONTY PYTHON REFERENCE)

Silly Walk off a Cliff, *The New Yorker* cover, July 4, 2016 (with sketch)

The timing of the Brexit vote left us with only a couple hours to come up with an idea, and this one was drawn in a complete panic. (I'm not complaining, I'm just telling you)

PRICE $7.99

JULY 4, 2016

THE NEW YORKER

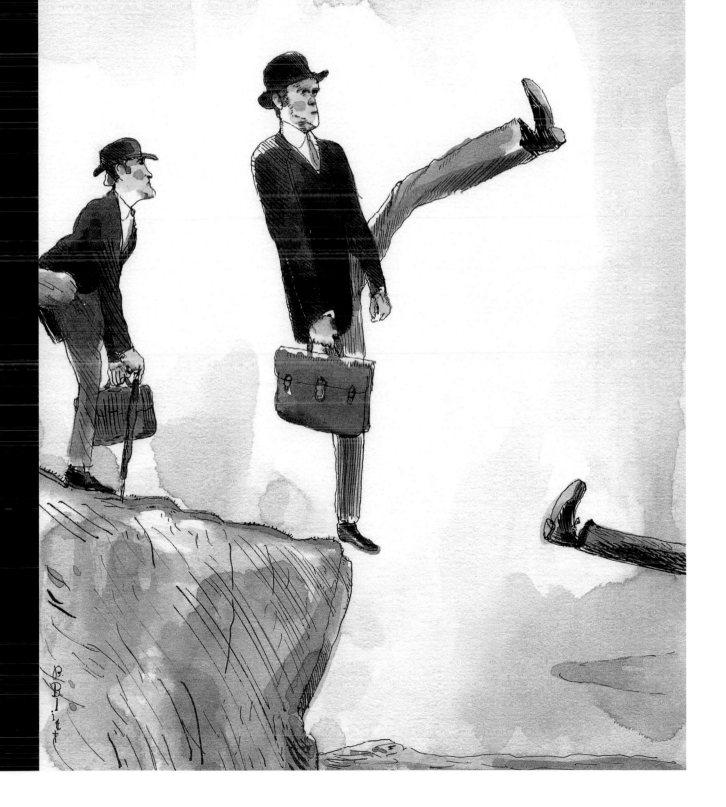

If only I had the guts to use this dazzling color →

Caked
shut since
2007
←

Permanent
White?
(who am I
Kidding?)

Barry Blitt entered my life in 2005 when the *New York Times* Op-Ed page hired him to illustrate my Sunday column for the weekly section then known as The News of the Week in Review. The idea was the brainchild of two unusually creative (and relatively young) *Times* hands, the Op-Ed editor, David Shipley, and the art director, Brian Rea (himself a gifted artist). This was no easy feat back in the time when the paper still saw itself as primarily a print enterprise. The editorial page editor, to whom Shipley and Rea reported, was a blustery autocrat better known for his nepotistic ties to the paper's management than his sense of humor. His next-to-immediate predecessor was notorious for killing any Op-Ed illustrations that faint-hearted readers might somehow construe to contain encoded phallic symbols. Historically, the *Times* had prided itself on having never run comics or editorial cartoons. Even as the twenty-first century dawned, there was still widespread suspicion in the upper-floor editorial-page

Cartoon Politics
(the OP-ED page, actually)
{Frank Rich's column, specifically}

precincts of the old Forty-third Street Times building, where writers and editors occupied quaint offices reminiscent of a second-tier liberal arts college, that graphic levity would tar the authority of the enterprise. By that point, the only great artist who had ever appeared regularly in the *Times*, the incomparable Broadway caricaturist Al Hirschfeld, had been prematurely retired from the paper's culture sections by an executive editor who found him frivolous and dated.

None of these institutional burdens impeded Barry, who worked as a freelancer from his home in Connecticut. Given that he and I had never met, it would seem counterintuitive that we hit it off creatively right away. Friends and readers were always astounded when I described our "process." My weekly deadline was Friday—the section was printed late that night—and by the previous Tuesday or so I would (usually) have an idea about what I was going to write. But not always promptly or conclusively, and not much of an idea: a topic, perhaps, and an embryonic narrative line or political argument. I would send this inchoate musing, usually just a brief paragraph, to Barry by e-mail. As Friday grew near, he would send two or three potential sketches to Shipley and company to pick a favorite just before a draft of my piece would land. These options were unseen by me. I would see only the finished drawing in a page proof I had to read at the last hour one final time before it went to bed. Yet to my astonishment,

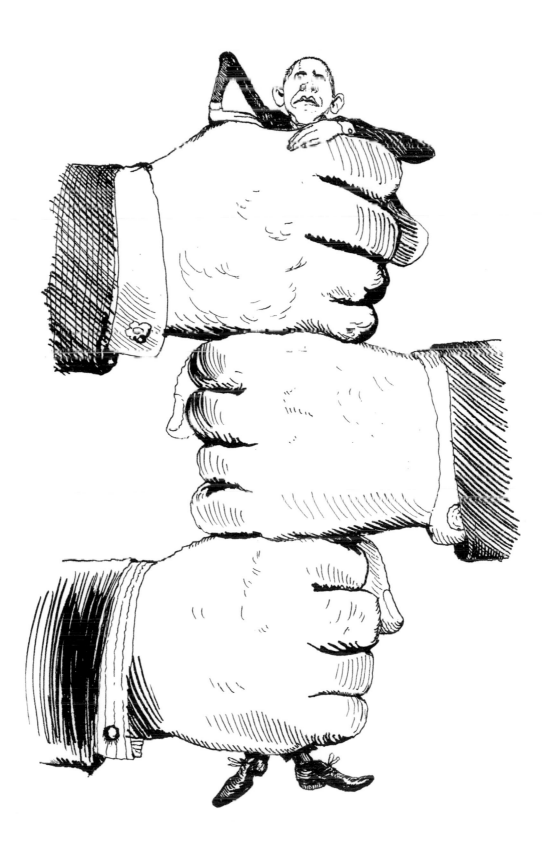

All the illustrations in this chapter originally appeared in *The New York Times* between 2005 and 2011.

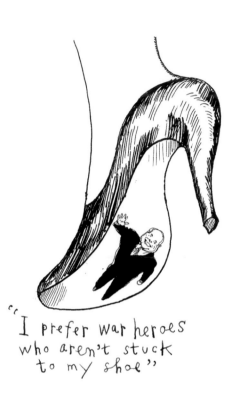

"I prefer war heroes who aren't stuck to my shoe"

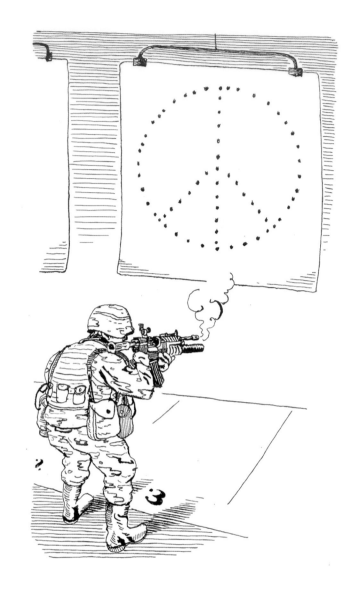

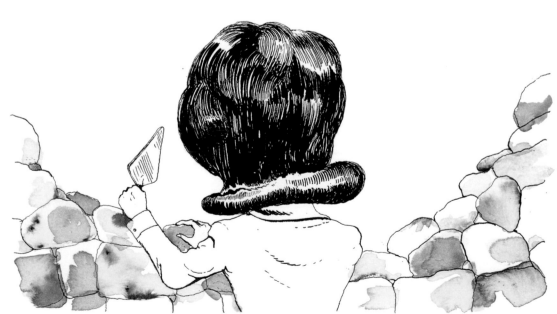

Condoleezza's haircut remains a distinct pleasure to draw from every angle!

there was almost always a synergy between my columns and his illustrations—a telepathic weekly miracle. No wonder many readers assumed that we were joined at the hip, in the same office, banging out our respective contributions in close collaboration.

It's impossible to summarize the spontaneity, grace, and power of Barry's art, which came in a variety of genres. Some of his drawings were stand-alone exhibitions of graphic and verbal wit. For a January 2009 column about the Republican party's inability to respond to the financial crisis, he drew a blind elephant in the guise of a Great Depression peddler wearing a sign saying "No Vision." (The headline of my column, unknown to Barry in advance, was "Herbert Hoover Lives.") To capture the idea of denial for a column I wrote about America's gun epidemic after the 2011 shooting of the congresswoman Gabrielle Giffords, he drew (and labeled) a whimsical assortment of target-shaped objects that studiously avoided any explicit associations with guns, from a vinyl LP to an "old TV test pattern (those were the days!)" to the "aerial view" of a wedding cake. For a 2010 piece about how Washington reporters were cavorting at the annual White House Correspondents' Dinner while a terrorist scare unfolded in New York, he drew a small catalog of eyeglasses, including those constructed from blinders, rose petals, and cracked lenses. When the CEO of General Motors was fired in 2009 at the height of Detroit's meltdown, Barry conjured up a fastidiously labeled diagram of an "Executive Guillotine" that was a cross between a luxury suite and a spa. Some of my favorite Blitts were so elliptical that they relied on readers to make the connections between his drawings and my columns. They loved doing so. A 2009 piece about John McCain's call for America to pour still more troops into Afghanistan showed an anonymous bureaucrat with a mallet attempting to tamp down various reptiles popping out of holes in a conference table.

The *Times* frowned on Op-Ed illustrators depicting actual politicians, but with time Barry succeeded in rolling back that stricture: he particularly enjoyed drawing McCain, Barack Obama, and Sarah Palin. But even these drawings didn't seem like the rapidly vanishing editorial cartoons of the newspapers I'd grown up reading—those by Herblock in my hometown paper, *The Washington Post*, for instance. Only in one 2007 illustration, I think, did Barry deliberately evoke that old-school heritage, in this case David Levine's legendary caricature (for *The New York Review of Books*) of LBJ revealing an abdominal scar in the shape of Vietnam. In the elegant Blitt variation, George W. Bush's furrowed forehead was reimagined as a map of his own expanding military quagmire.

When I decided to end my *Times* column in 2011, Barry surprised me yet again, by intuiting what was inside me, as he always had what was inside my columns: He drew a writer leaping out of a window, held aloft by an umbrella, in heady celebration of his freedom. By then, David Shipley and Brian Rea had left the paper, as would Barry. The whole business of what is now known as "print journalism" was soon to be on its way out as well, but not before a singular artist left an enduring imprint on its final chapter. —Frank Rich

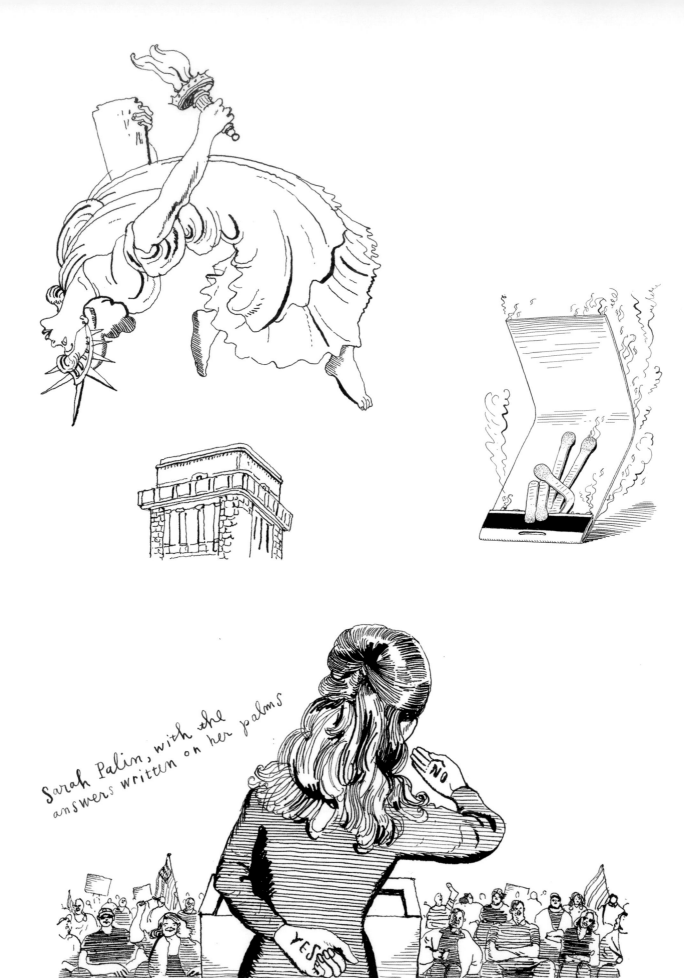

Sarah Palin, with the answers written on her palms

(Something to do with Salvador Dalí, I think)

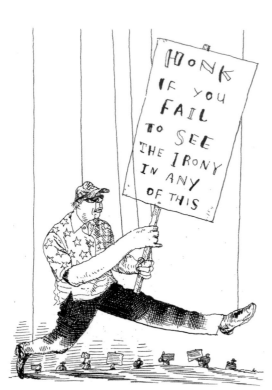

Why talk when you can yell?

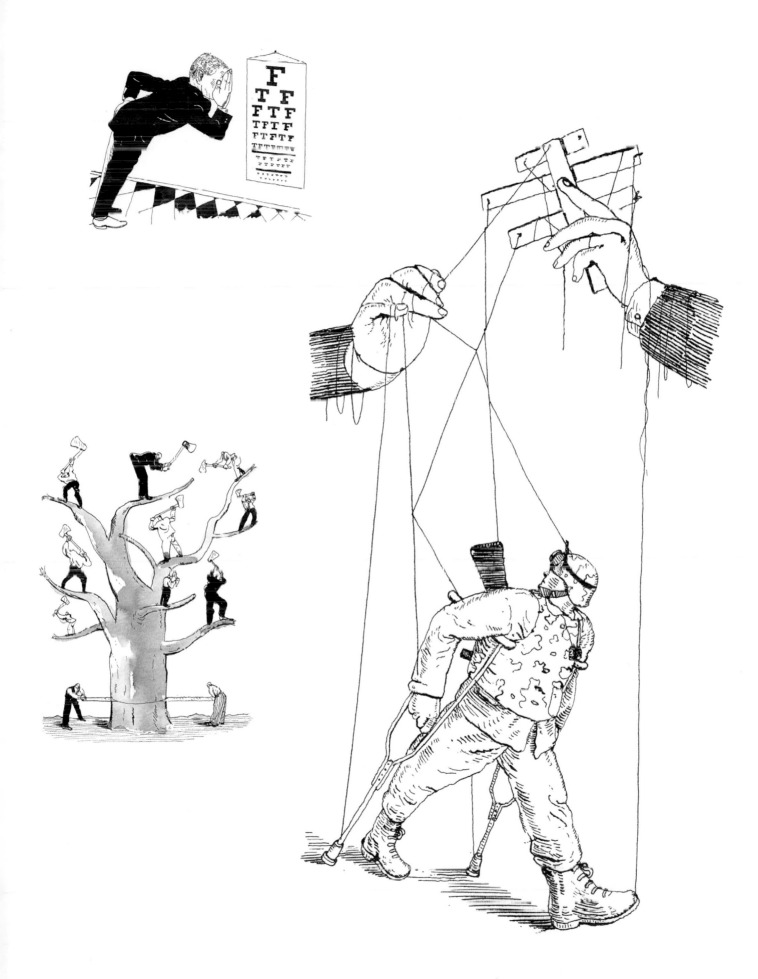

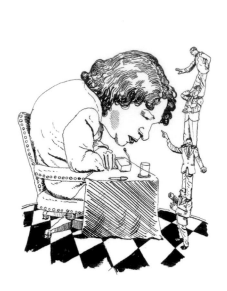

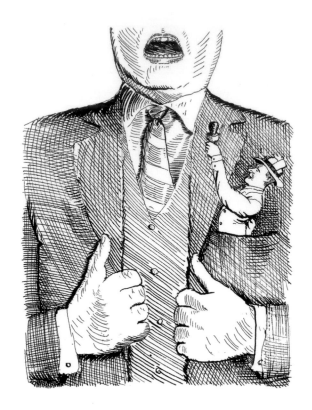

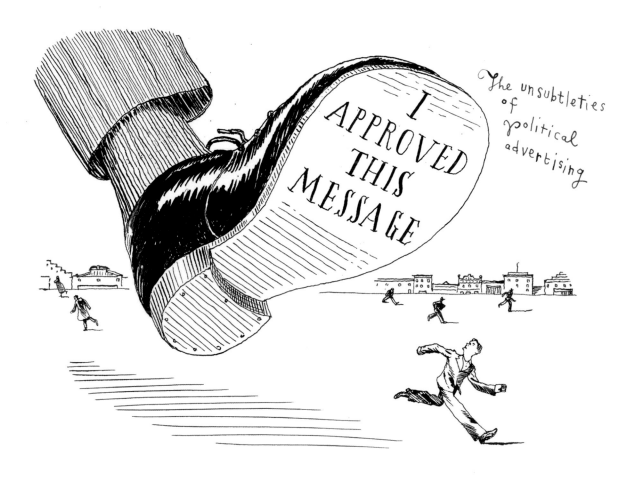

The unsubtleties of political advertising

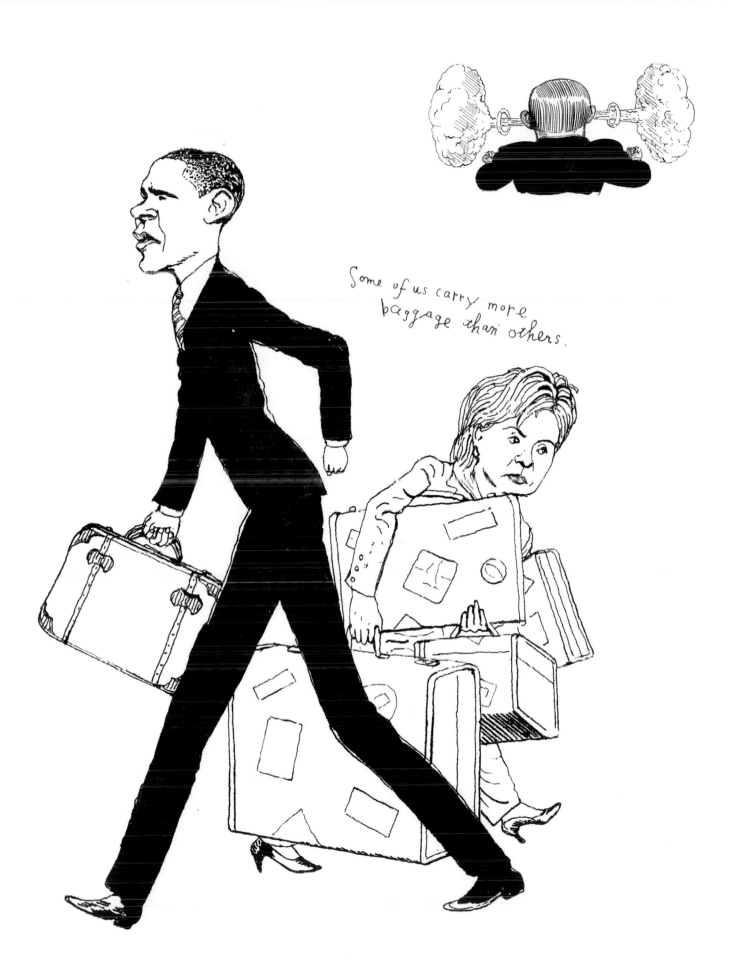

Some of us carry more baggage than others.

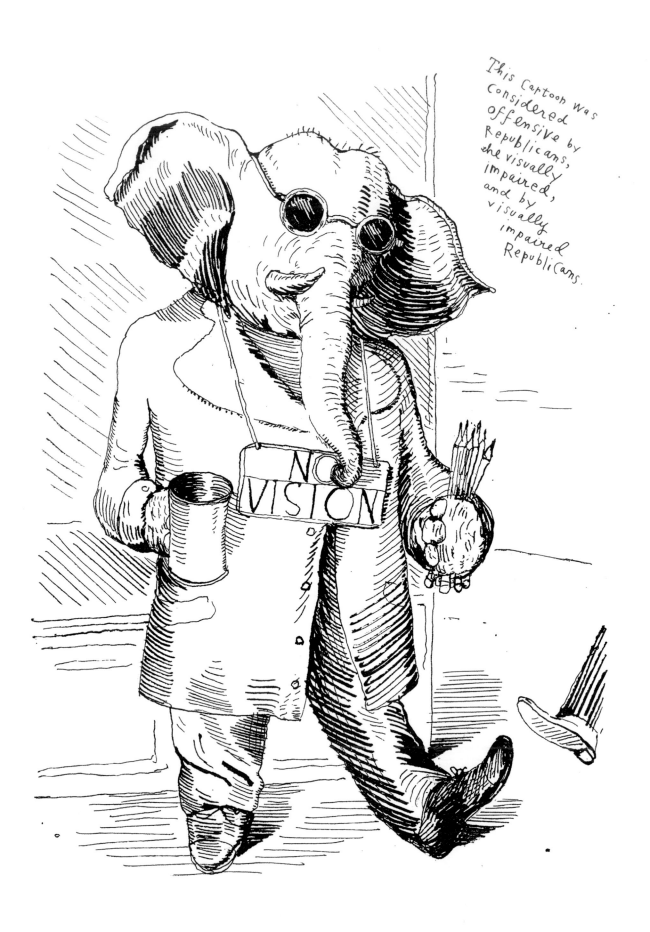

This Cartoon was
Considered
offensive by
Republicans,
the visually
impaired,
and by
visually
impaired
Republicans.

abroad

at home

Who do you see in this picture? (HINT: it's OBAMA)

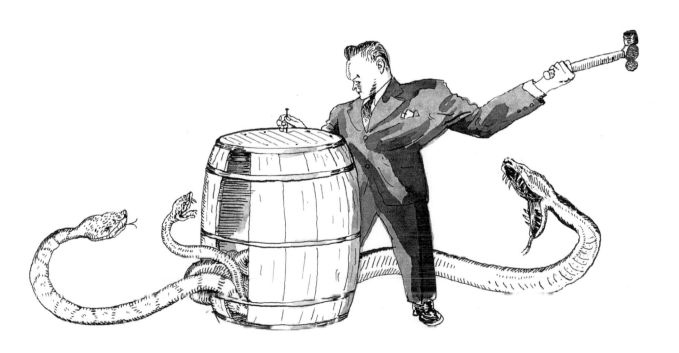

Whitewashing
the War
(any War)

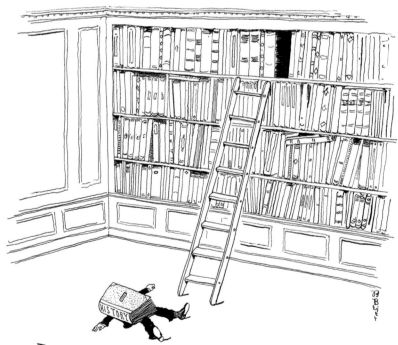

The weight of history

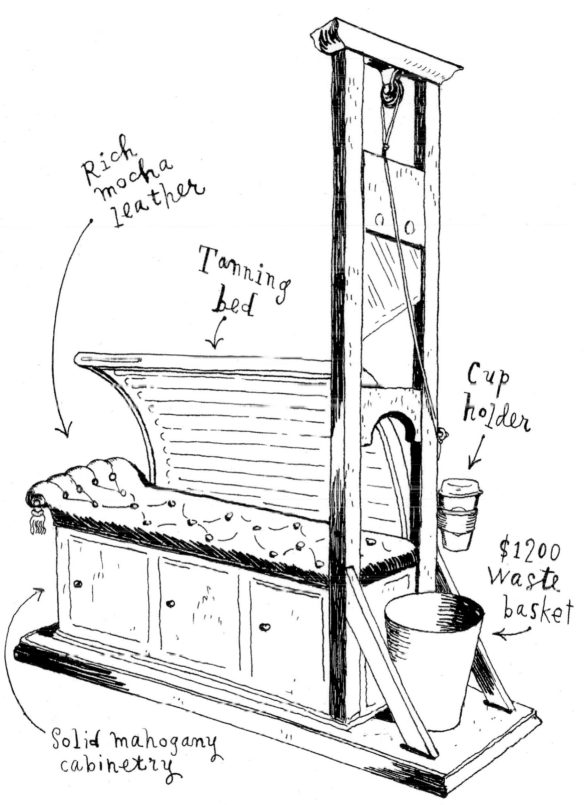

Rich mocha leather

Tanning bed

Cup holder

$1200 Waste basket

Solid mahogany cabinetry

EXECUTIVE GUILLOTINE

(Looks comfortable – though it may need a bigger bucket)

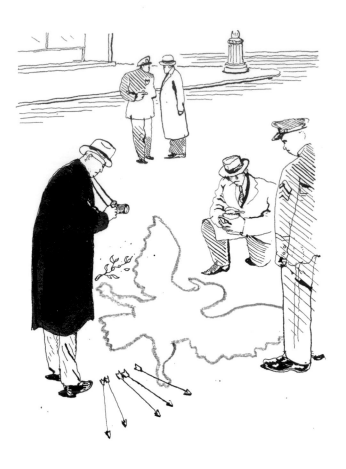

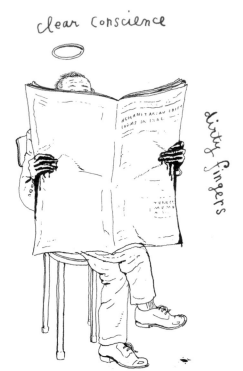

clear conscience

dirty fingers

putting the "bull!" in bullseye ↓

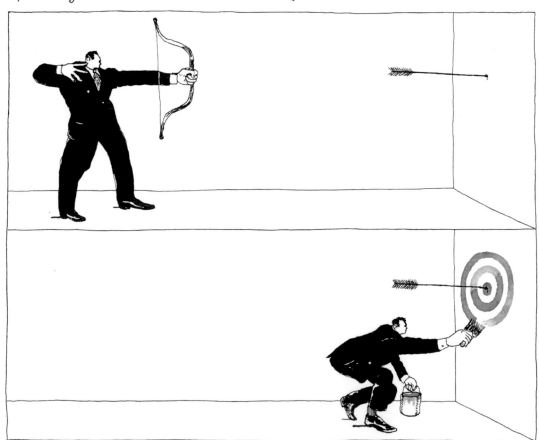

Ear to the ground

Head in the sand

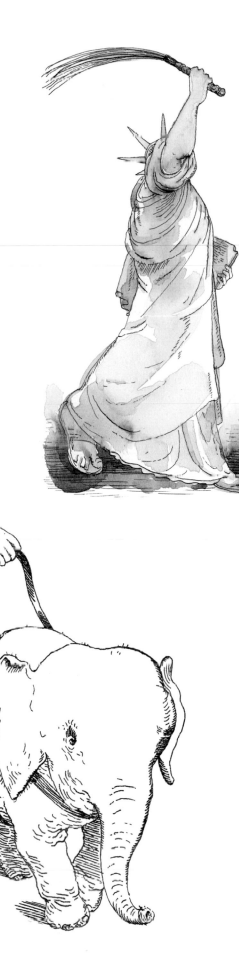

a little heavy with
the metaphors here, pardon me

Emoticon

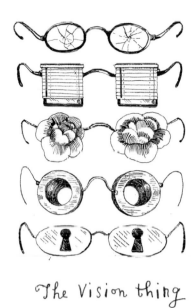

The Vision thing

Things are looking up. Sort of. (a bit)

After the Tea Party used firing range targets in an ad (to highlight political opponents), and then denied they were marks to shoot at...

Surveyor's Symbol

Orbit of planets around the sun

Wedding cake (aerial view)

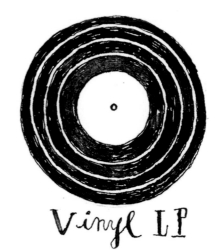

Vinyl LP

Toothpicks in an avocado pit

Old TV test pattern (those were the days)

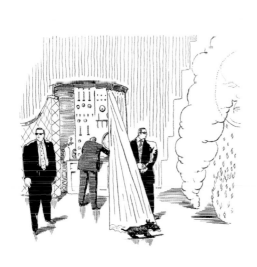

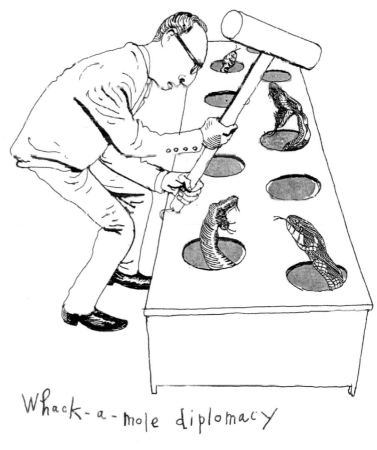

Whack-a-mole diplomacy

GOP. paint by numbers
(note the limited palette)

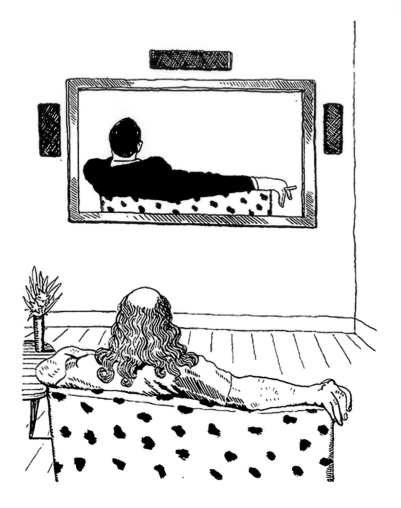

This picture was drawn with a spoon

This gesture was taken from "Self Portrait, Yawning" by Joseph Ducreux (French, 1735-1802). Obviously

1.

2.

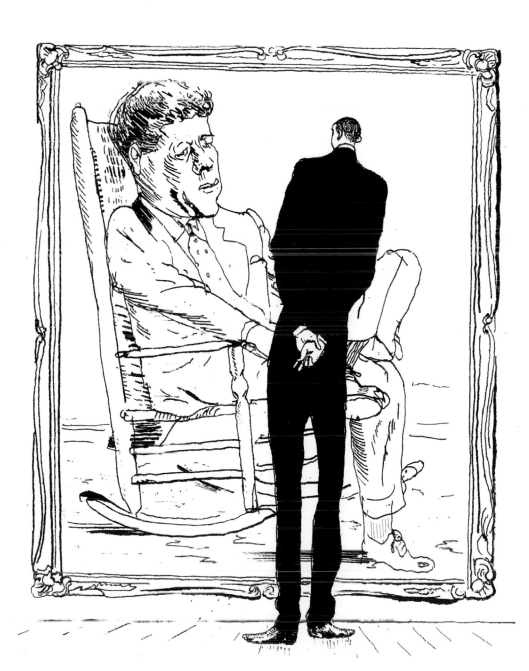

BHO channels his inner JFK

Tools of the trade:

(Tools of the trade, cont'd)

Process

The most important tool a satiric artist can have is a space to play. When you look at a finished piece of art in a magazine or a newspaper or on a website, you are seeing the result of many happy (or miserable) hours of deep immersion in an inner conversation in which the child part of the artist's mind rampages about mashing things together, slicing them apart, seeing them in altered states. Later the adult brain visits this wreckage and pronounces some things "okay" or not. If something gets an okay from the grown-up brain, the child brain, now reasonably encouraged, will start focusing on how the concept can be given the best possible approach. The major objective is always to create that moment when the piece's elements hit the eye of the viewer in the most precisely correct way, igniting a laugh. Nobody is better at this than Barry Blitt.

In "Great New Starter Homes" we get a peek into this sausage-making process. We see the project he gives himself: how to mark the dearth of affordable housing by promoting and celebrating pathetic situations. The satire, of course, comes from the unstated wink he gives the viewer, acknowledging that we all agree on the hopelessness of the issue and that a piece that kind of dances at the funeral will be fun for at least a few minutes. Okay, so now the game is, what small

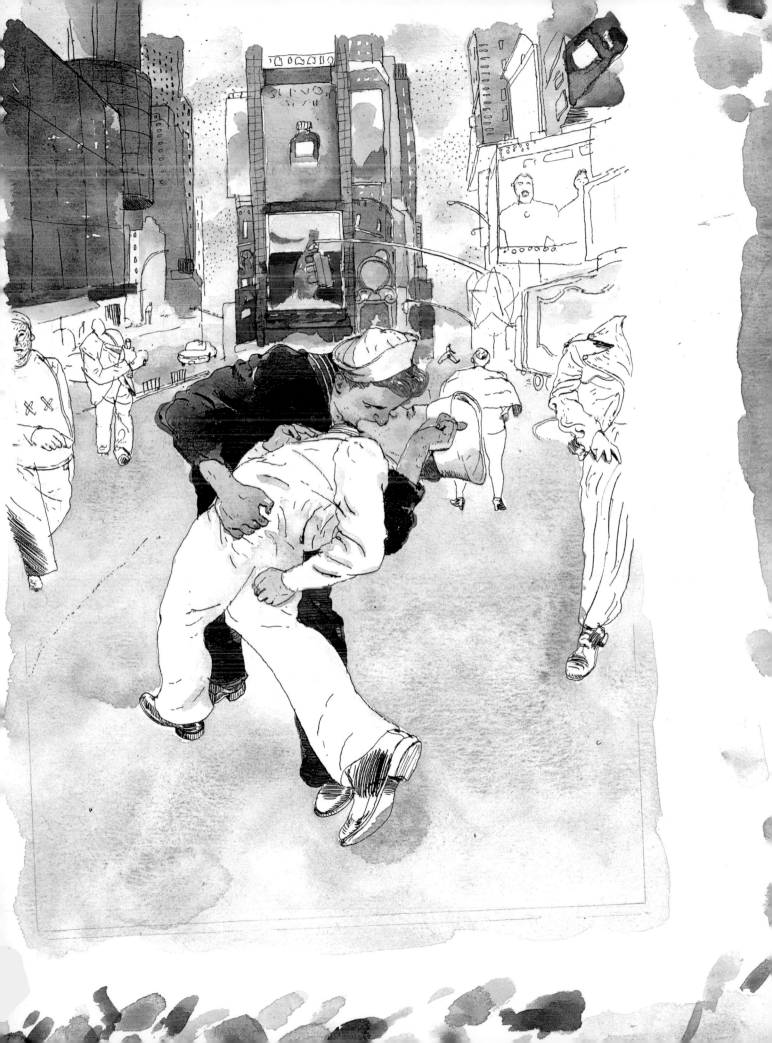

Barry Blitt by Steve Brodner

Thanks for flattering me, Steve!
(I'm not quite as tall as
I appear here)

vignettes will best do this? There's an idea of sleeping in an IKEA bed, a KFC bucket sign, what looks like a filing cabinet, and perhaps a hot dog stand, along with scribbled notions about a fireplace. We see the thing beginning. I call this "listing." Throwing it all down: good, bad, worse. There's a famous saying, "Write drunk, edit sober." In a sense there is a bender you need to get on. Later, you can decide which of these isn't a total waste of time. But see the freedom here. Start anywhere and let the sketching take you where it wants to go. In each spread we see Barry give himself the theme: "Where Are They Now?" "Kids' Book Ideas," "Museum of No Sex," "EW Year End," "How They Really Stack Up: Hitler/Bush." He is saying to himself, "Here's the game. Go!" Then come the mash-ups. This is a test of the idea that you are submitting in your pitch. A majority of these vignettes need to be strongly funny, say level nine or ten. If you come close to that, you are allowed a ringer or two—funny, say, at level four or five. Sometimes, of course, ideas seem funnier before you begin to work on them, and after a while the thing needs to be put to bed or be visited later. Certainly ideas that are taking off have priority. In "Halloween: Who Is Wearing Who," we see his juices are really going. Madonna, SpongeBob, etc. It all tumbles out, collides, crashes around the page. It starts to take shape.

In the process there is a second level of sketching, which I call "staging." This is where an idea that has potential gets introduced to the world of design. Here it gets jiggered around until the composition serves the idea beautifully. Yes, no matter how satiric, biting, or morose the piece, it must also be beautiful. Elements must be clear and seen in the correct order, without neglected or distracting areas to confuse or turn off the viewer. You must be serving a delicious dish in which the flavors are controlled by you. Then we see some of Barry's finished sketches leading up to his most famous *New Yorker* covers. His sketching here is taking these designs very seriously. He gets the design down and plays with likeness, scale, and attitude. The further along in the process, the more minute the decisions: What's the placement of the spoon Obama is using to deliver the medicine? And which angle of Obama's head is best? In another, how do Trump's short fingers really look? The miracle of Barry is how much sweat we do not see. There is, in every step of the process, the same elán, finesse, and mastery of screwball comedy that makes him unique in all the world. No issue is too dark for him to find a sane, wry aspect to. Humor is a knowing experience shared with readers and, when done by a master, deeply satisfying. But be advised, Barry is also a master illustrator. He deeply understands the many ways in which a piece can be made stronger through tone, contrast, composition, excellent draftsmanship, pen calligraphy, color concept, and painting technique. In every piece I have ever seen by him he uses all these tools at the highest level of skill. It is not just for these reasons that we love his work. It is because of his profound understanding of the human condition, which is evident in every line he draws, that we keep this artist close to our hearts. —Steve Brodner

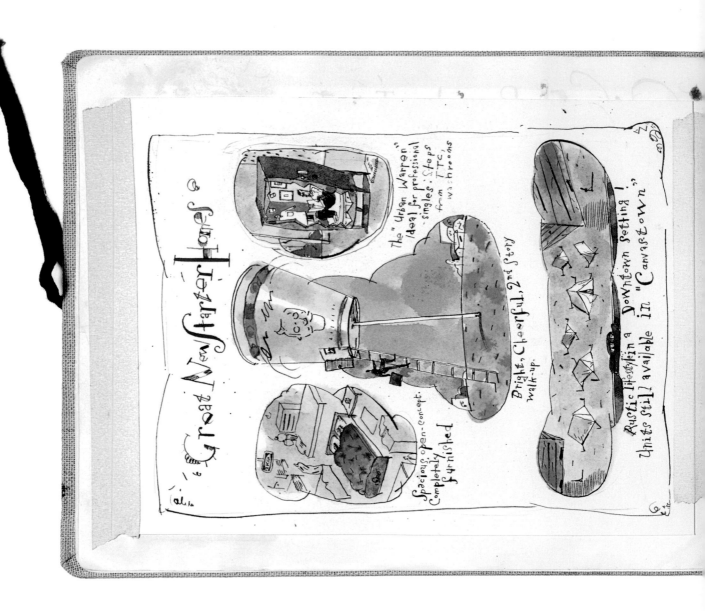

"Great New Starter Homes"

Spacious, open-concept.
Completely Furnished

The "Urban Warren"
Ideal for professional
singles. Steps from TTC,
washrooms

Bright, Cheerful, 2nd story
walk-up.

Rustic lifestyle in a Downtown Setting!
Units still available in "Canvas Town"

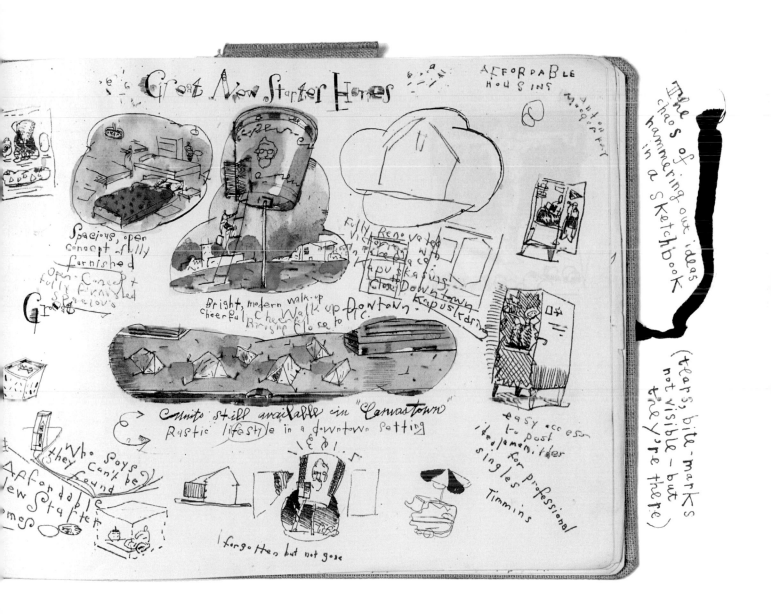

Working sketch for Great New Starter Homes for *Toronto Life* magazine, 1987

Okay, okay,
alright,
already

August 20 of this wretched hot summer of 2002. I feel like I'm 70 years old.

CAUTION:
CONTENTS
UNDER
PRESSURE

BOMB-MAKING WITH MARTHA

HOW THEY REALLY STACK UP

HITLER	BUSH
FATHER OF GENOCIDE, BARBARISM	FATHER OF JENNA, BARBARA
LEAD THE NAZI PARTY	ATTENDED SOME NASTY PARTIES
MADE THE TRAINS RUN ON TIME	DEFUNDED AMTRACK

The New Neutrals

Wan Faucet Floss.

STAMPS ISSUED
(WARNING: PUNS)

TOM POSTON

DAVE LETTERMAN

TERRENCE STAMP

JACK ("THE POSTMAN ALWAYS RINGS TWICE")
NICHOLSON

SENDER
BOX?

MAYBE

- PARCEL
- DELIVERY
- 1ST CLASS

94

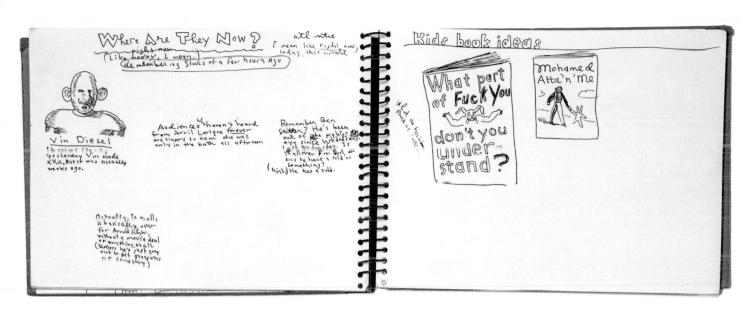

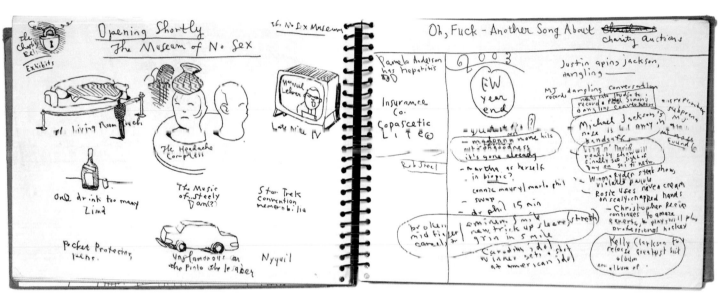

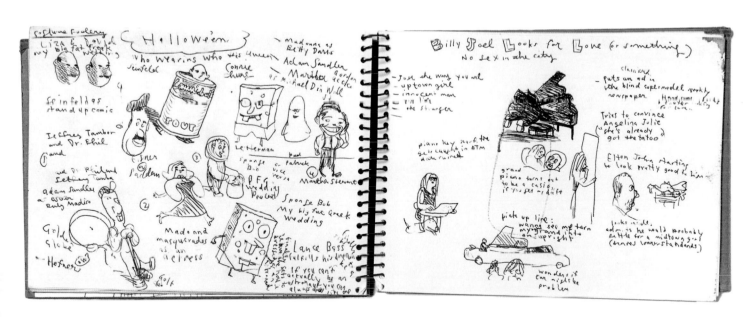

Sketchbook pages (working out cartoon ideas) *(and personal problems)*

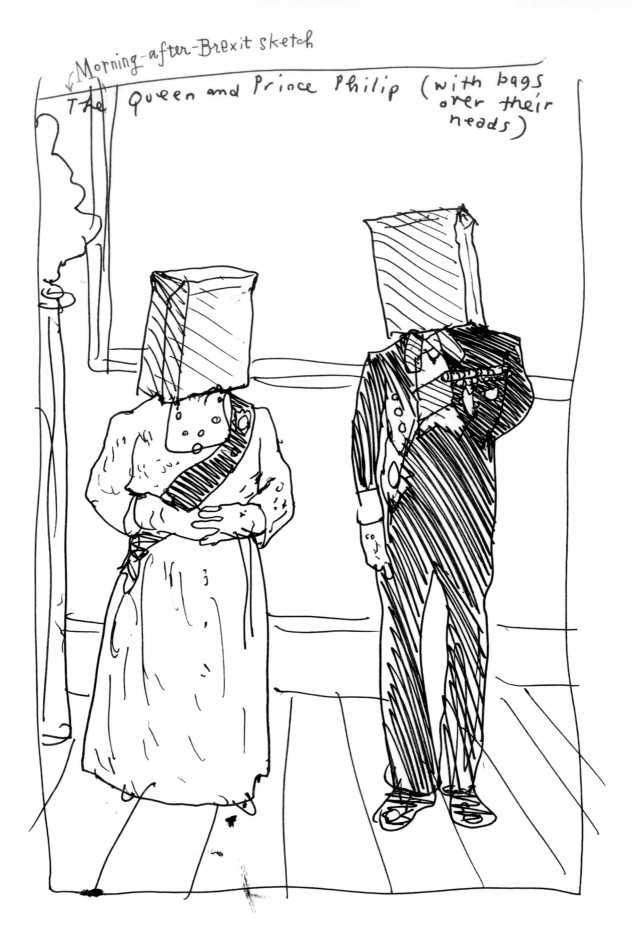

Morning-after-Brexit sketch

The Queen and Prince Philip (with bags over their heads)

Several ideas that made it out of a sketchbook and onto faxable
sheets of paper, sent to *The New Yorker* with varying levels of success

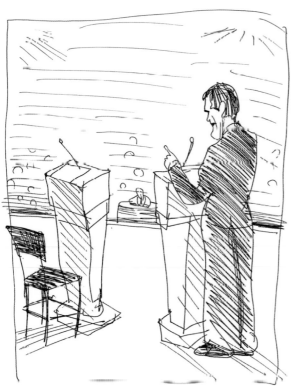

← Empty chair (Mitt Romney,
channelling Clint Eastwood)

← Occupied stall

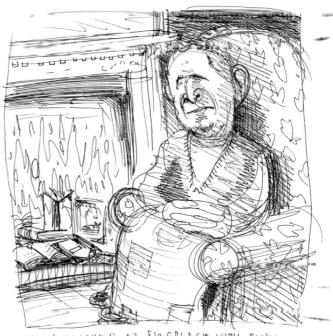

BUSH RELAXES AT FIREPLACE WITH BOOKS

Ahmadinejad channelling Larry Craig

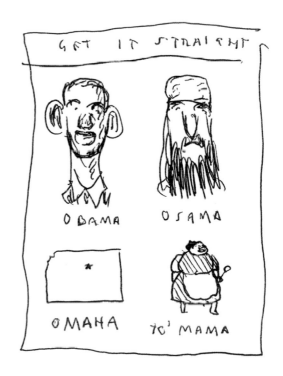

GET IT STRAIGHT

OBAMA OSAMA

OMAHA YO' MAMA

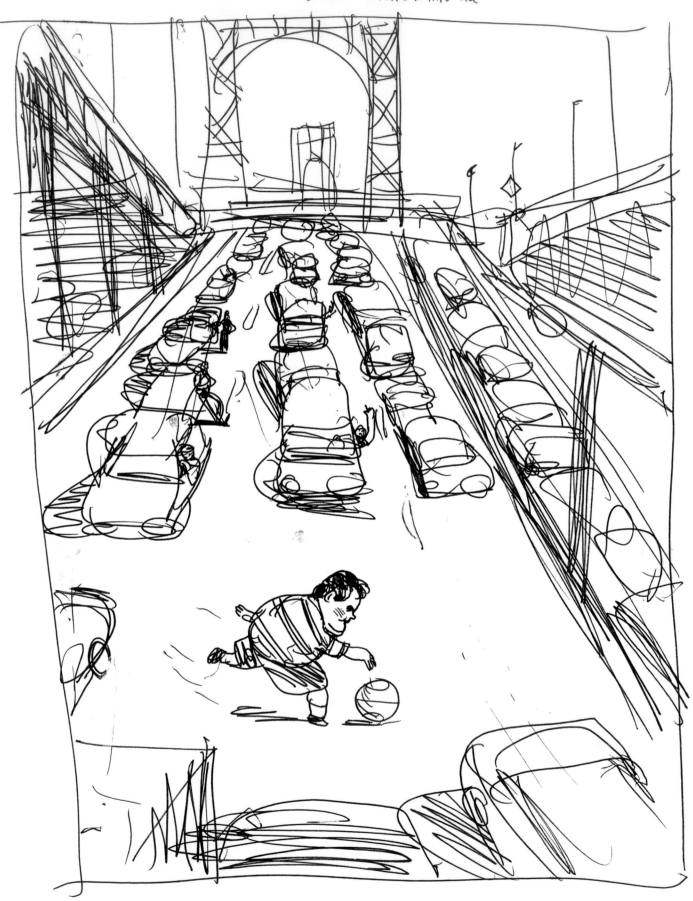

I've had panic attacks in traffic on the G.W. Bridge (on all the major N.Y.C. bridges, actually) so I relished skewering Chris Christie in this one

The original sketch and an abandoned attempt at the final art for
Playing in Traffic, *The New Yorker* cover, January 20, 2014

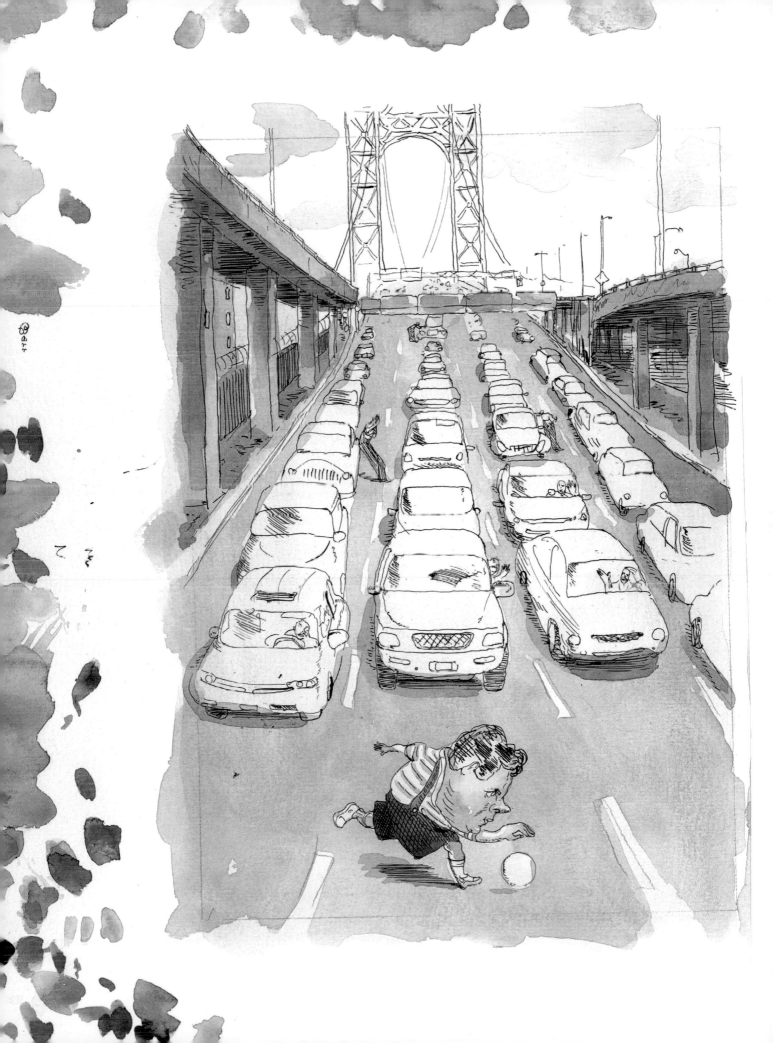

(I suppose this one never had much of a chance)

More *New Yorker* cover sketches, and a couple of wannabes *(opposite, top left and right)*

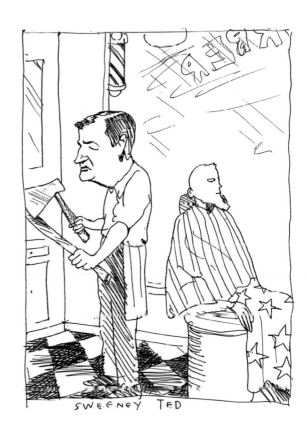

SWEENEY TED

Super Bowl fun for Barack (watching Mitt and Newt slug it out in the 2012 GOP primary)

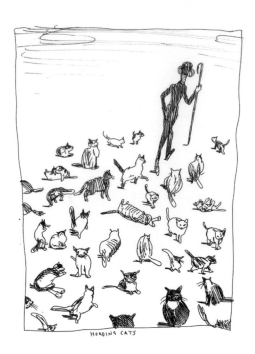

HERDING CATS

AUNTIE DEPRESSANT

MONKEY'S UNCLE

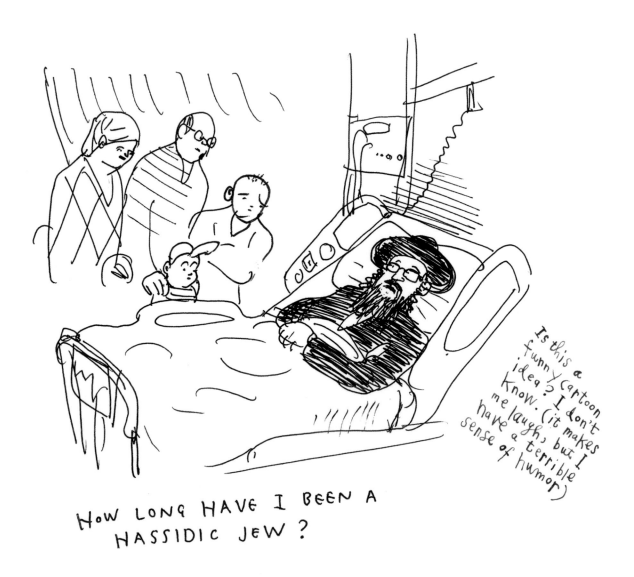

HOW LONG HAVE I BEEN A
HASSIDIC JEW?

Is this a funny cartoon idea? I don't know. (it makes me laugh, but I have a terrible sense of humor)

Sketches submitted to *The New Yorker* (*top left and opposite page*) and unsubmitted to anyone (*the rest of them*)

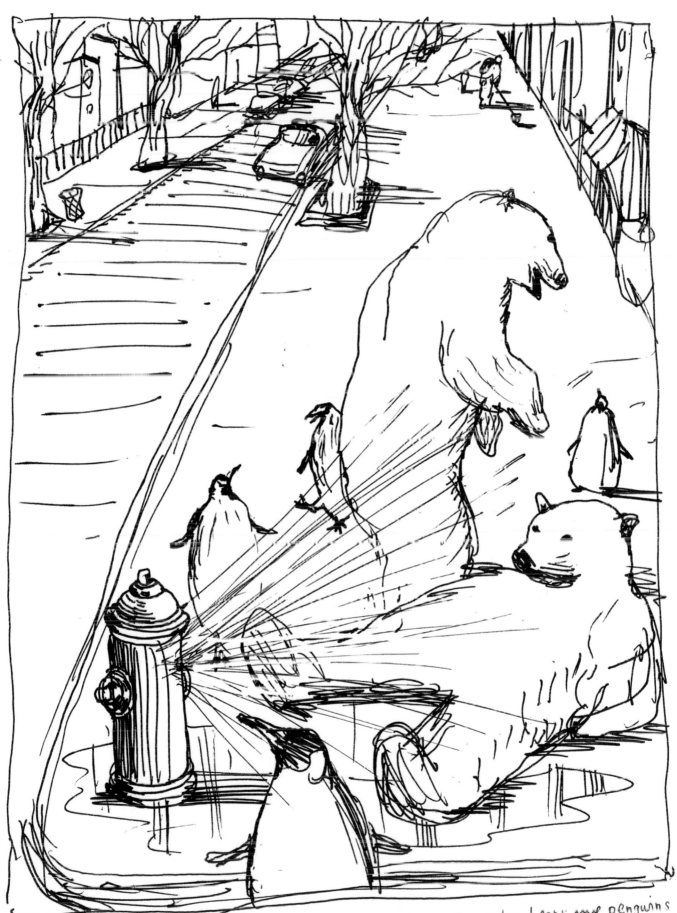

My two cents on climate change. (It was later pointed out that polar bears and penguins are from opposite poles, and would never encounter one another) (Go Know)

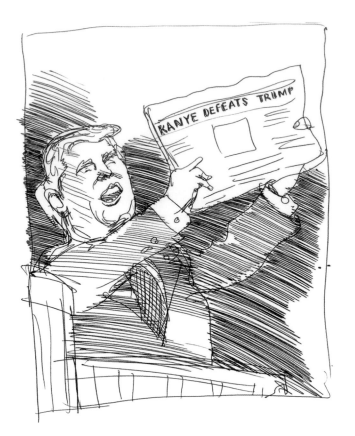

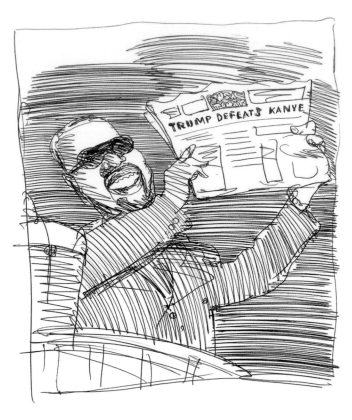

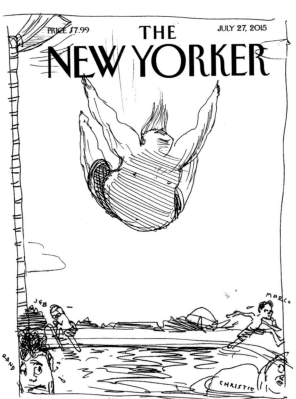

THE NEW YORKER

PRICE $7.99 JULY 27, 2015

SUMMER TRUMP

My very first Trump cover idea.
(I think I only encouraged him)

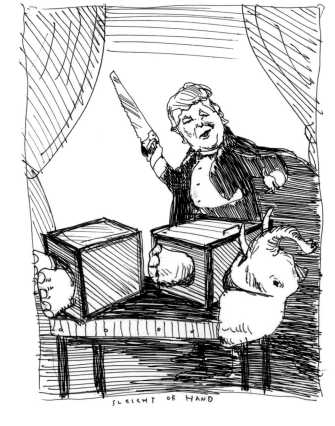

SLEIGHT OF HAND

Several whacks at Donald Trump (so to speak), a few of which actually became *New Yorker* covers

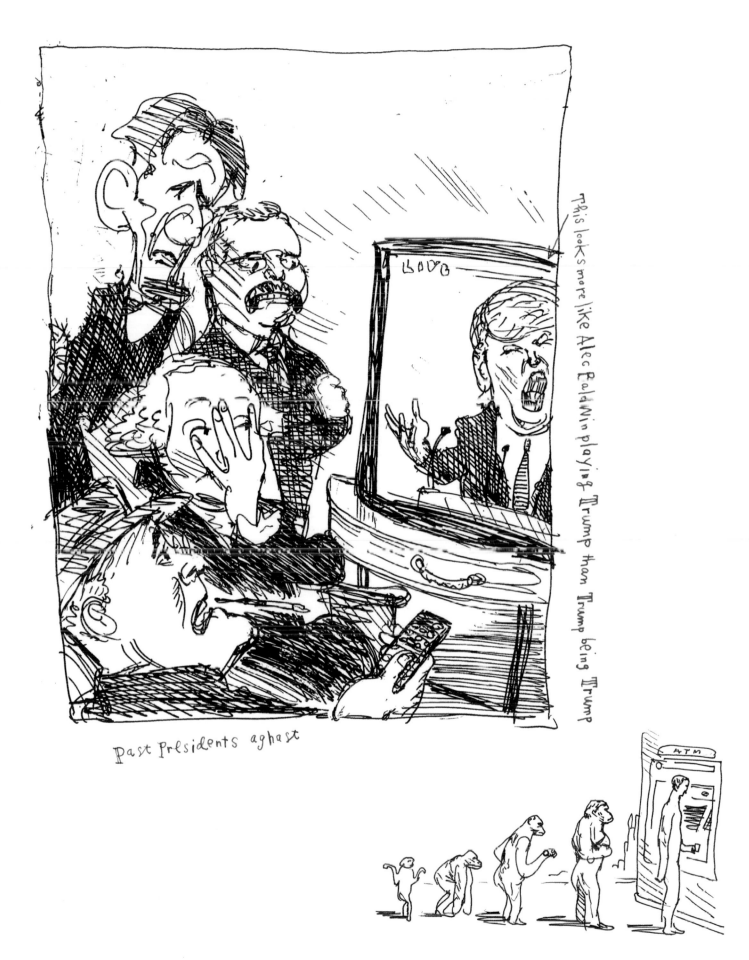

Past Presidents aghast

This looks more like Alec Baldwin playing Trump than Trump being Trump

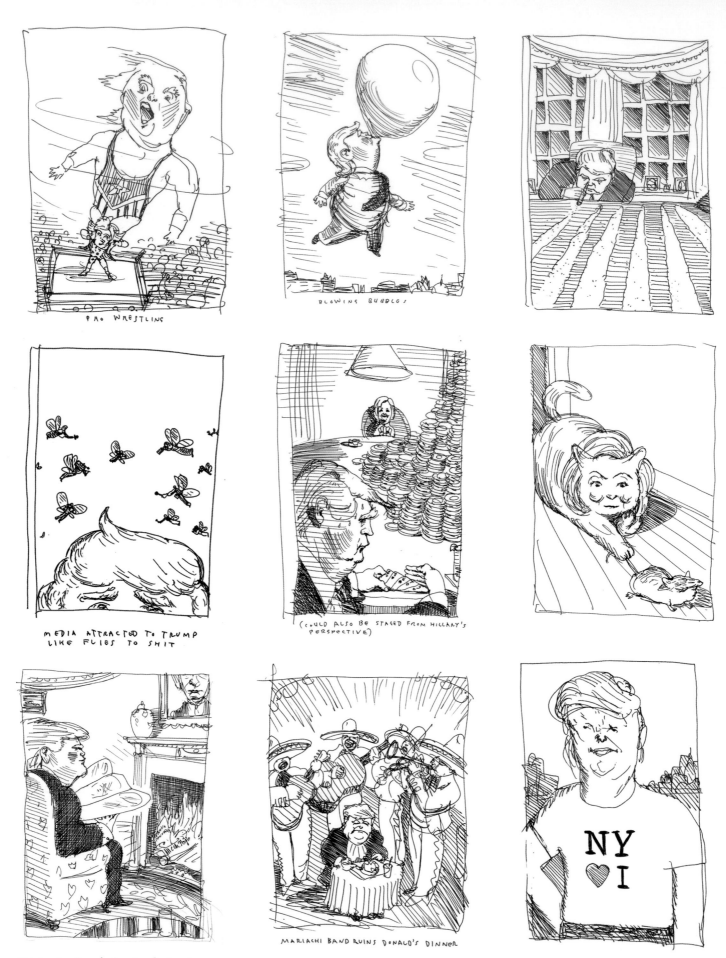

This is the kind of Work that, done over time, really ages you

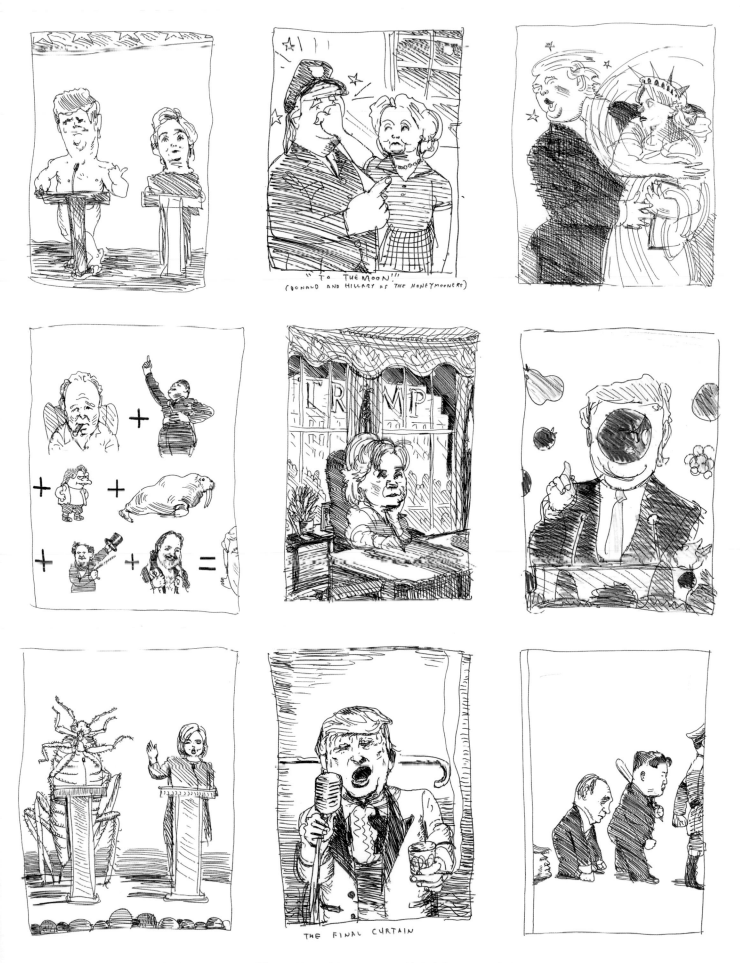

Still more sketches of Trump. None of these became published illustrations, for better or worse.

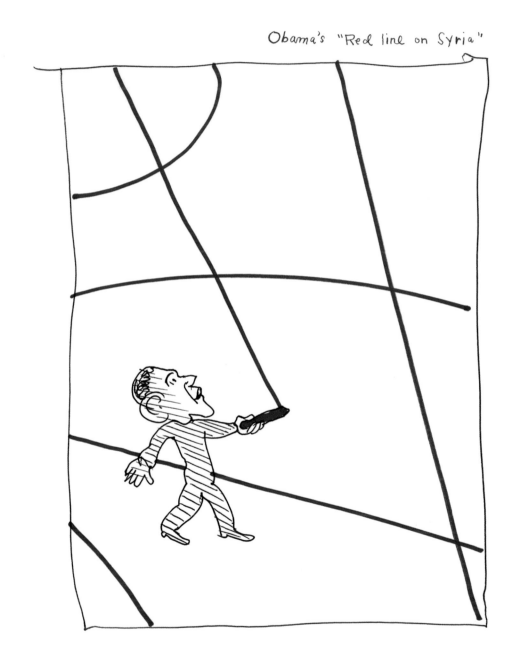

Obama's "Red line on Syria"

Above and opposite: Rejected *New Yorker* ideas

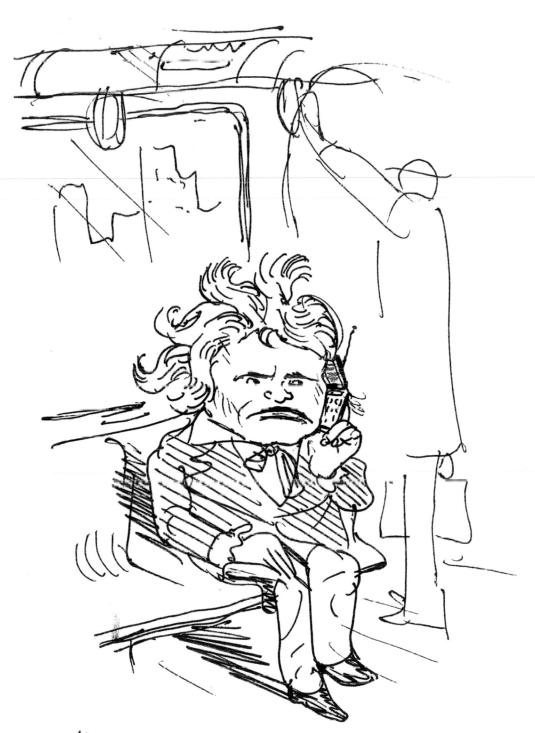

"SORRY, I CAN BARELY HEAR YOU"...

A Beethoven cell phone joke. (You just know what his ring tone would be)

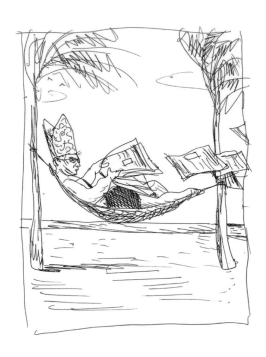

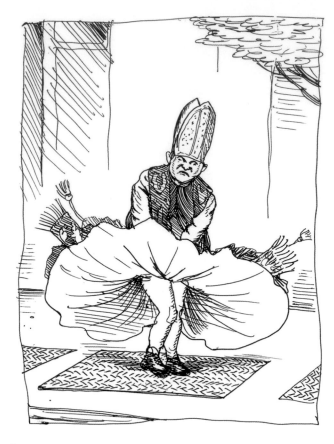

I pitched a lot of Papal sketches to the NEW YORKER. Most were rather cheeky, but several tamer ones made it to the magazine (top left, and this guy →)

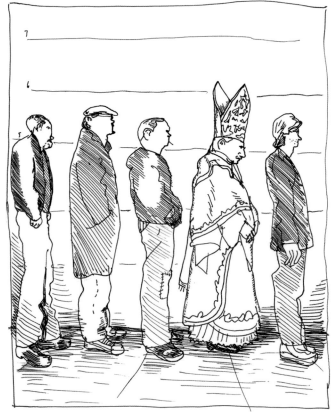

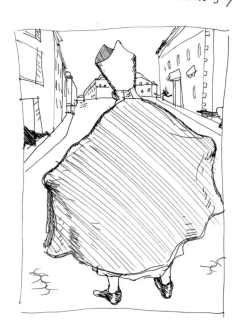

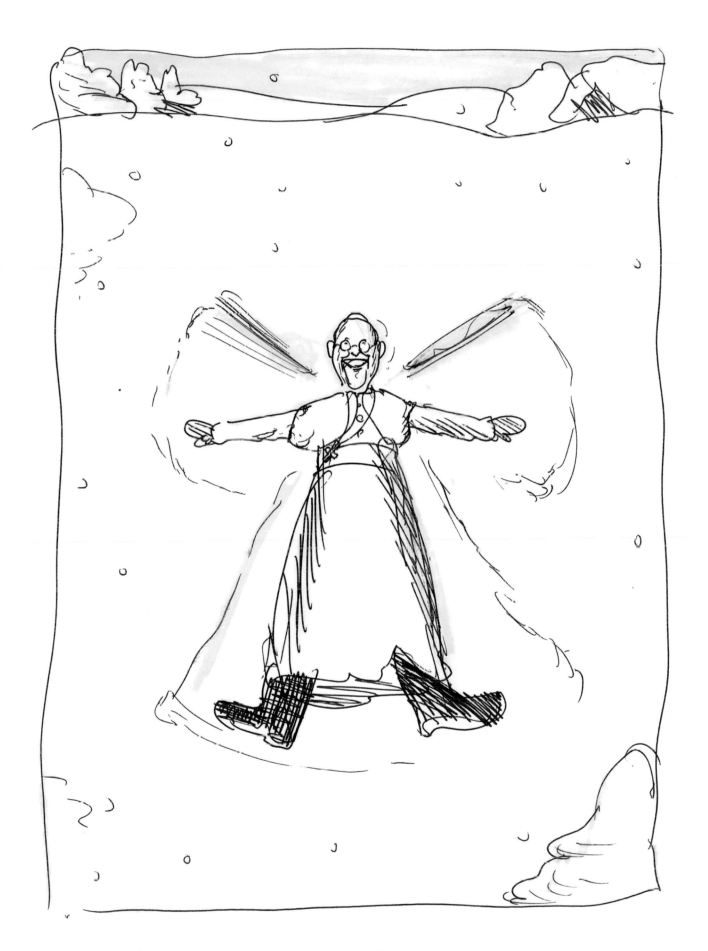

Above and opposite: Some good clean pope cartoon ideas

I think it was Françoise's idea to add the car interior, so we could see the taxi driver's reaction. (thanks, F!)

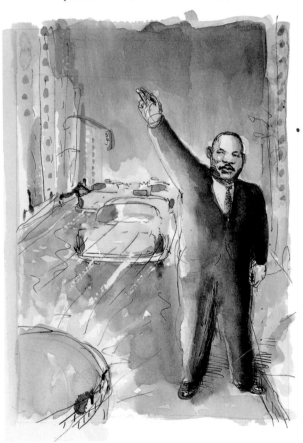
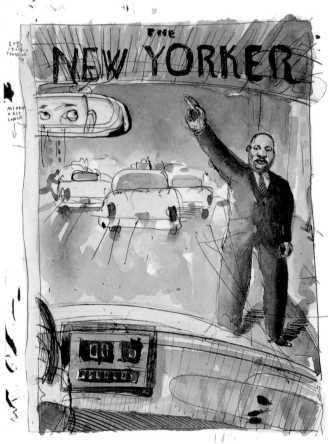

Hailing Dr. King, *The New Yorker* cover, January 17, 2000 (with sketches)

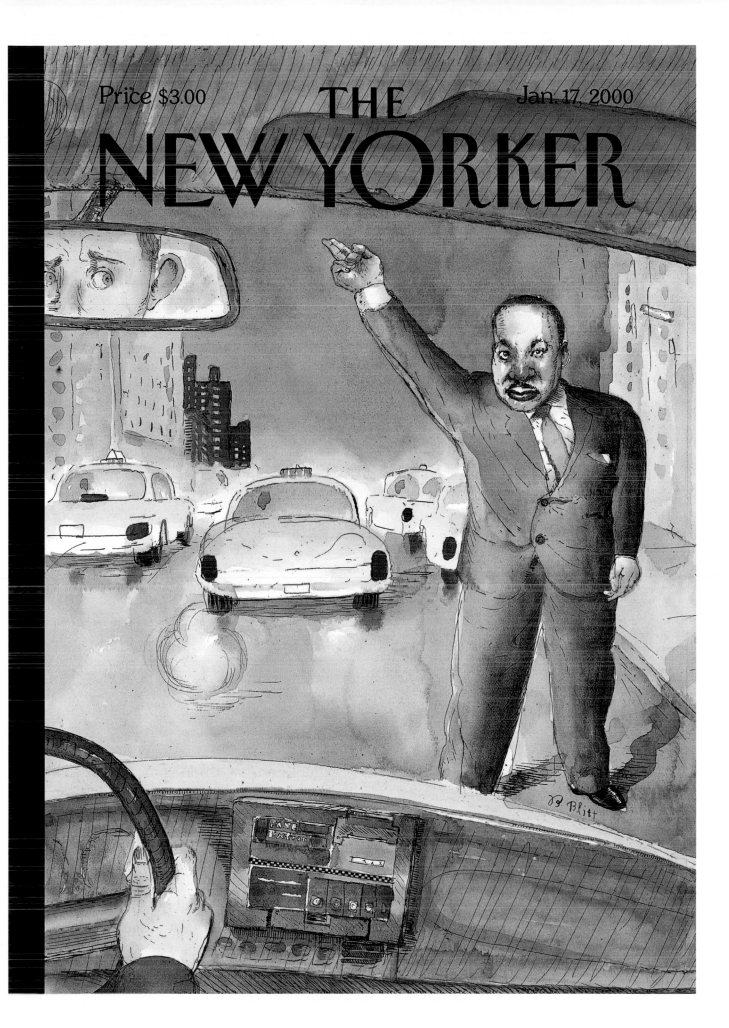

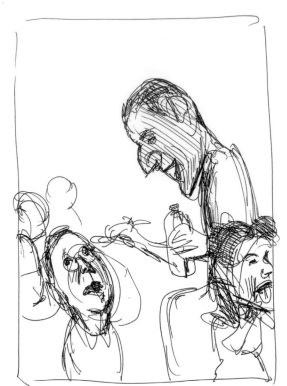
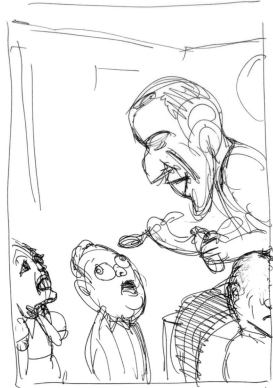

Feeling around blindly in the sketch stage (I usually save my uncertainty for the final art)

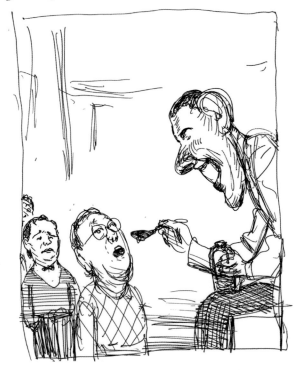

OBAMA MAKES SURE CRUZ, MCCONNELL ET AL GET THEIR MEDICINE

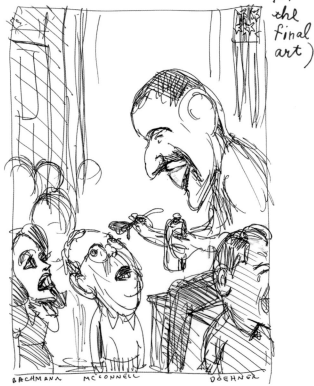

BACHMANN MCCONNELL DOEHNER

The Best Medicine, *The New Yorker* cover, April 14, 2014 (with sketches)

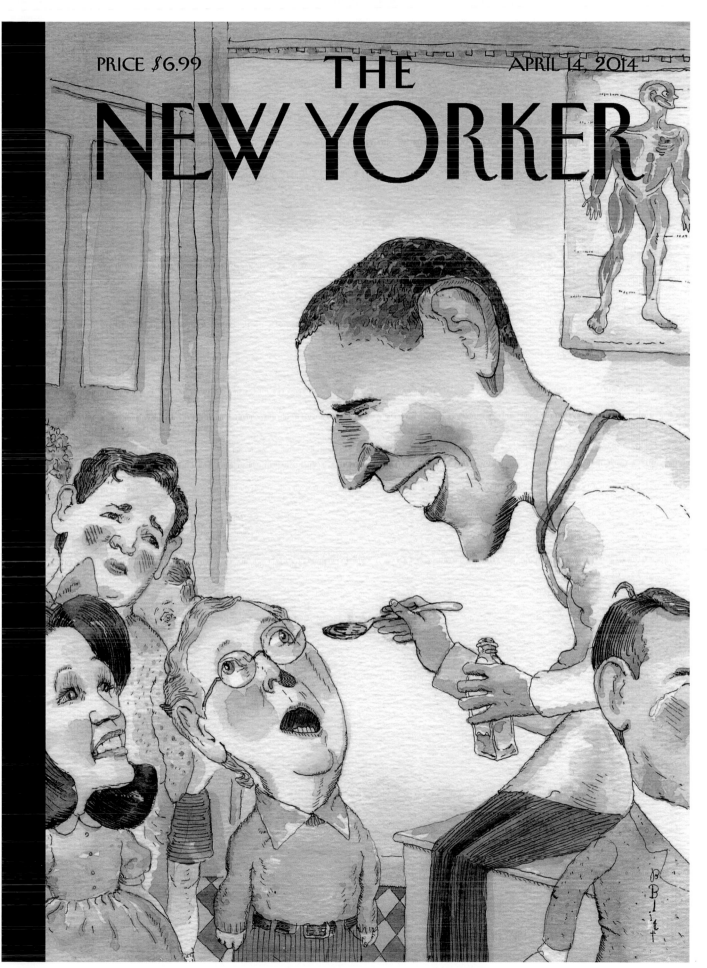

PRICE $6.99

APRIL 14, 2014

THE NEW YORKER

Not sure what I was thinking re: Obama's legs here

~~pointless repetition~~

~~repetitive stress~~

SEVENTY-TWO VERSIONS

~~once more, with feeling ...~~

~~STARTING OVER~~

~~pointless repetition~~

[e t c .]

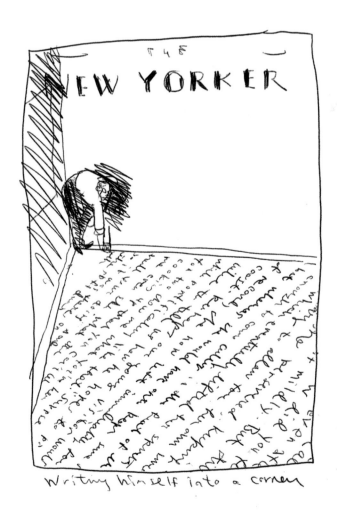

Writing himself into a corner

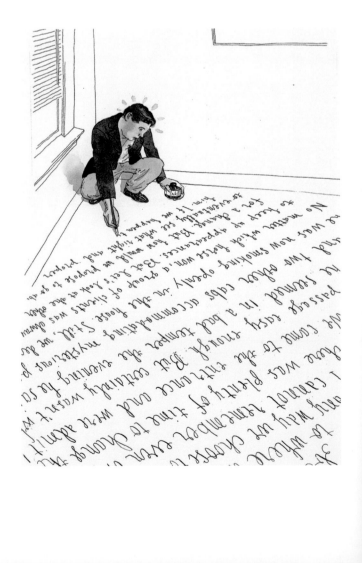

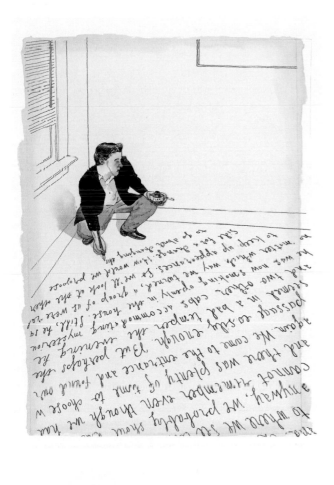

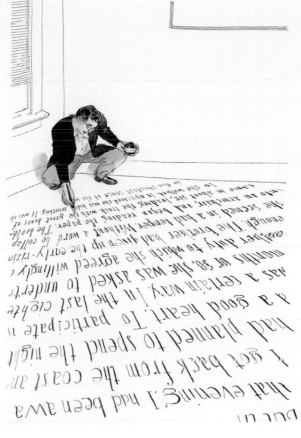

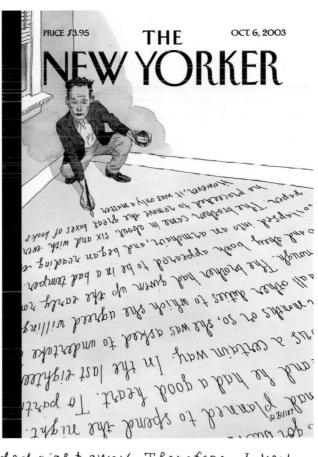

This cover was not "topical," so it wasn't needed right away. Therefore I kept drawing and redrawing it, until it was taken away from me. (of course, the first version was the best one)

Writer's Dilemma, *The New Yorker* cover, October 6, 2003 (with sketches)

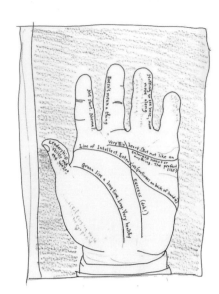

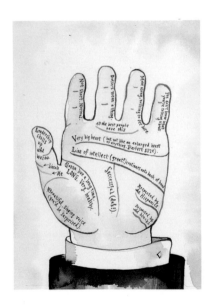

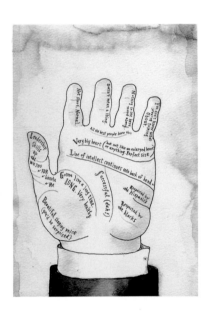

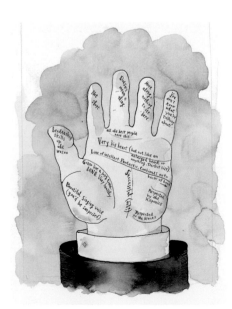

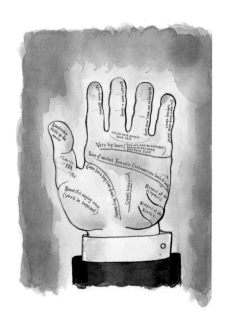

Working out the jokes for a short-fingered palmistry chart of you-know-who, written in his blustery/defensive vernacular

The Big Short, *The New Yorker* cover, March 28, 2016 (with sketches)

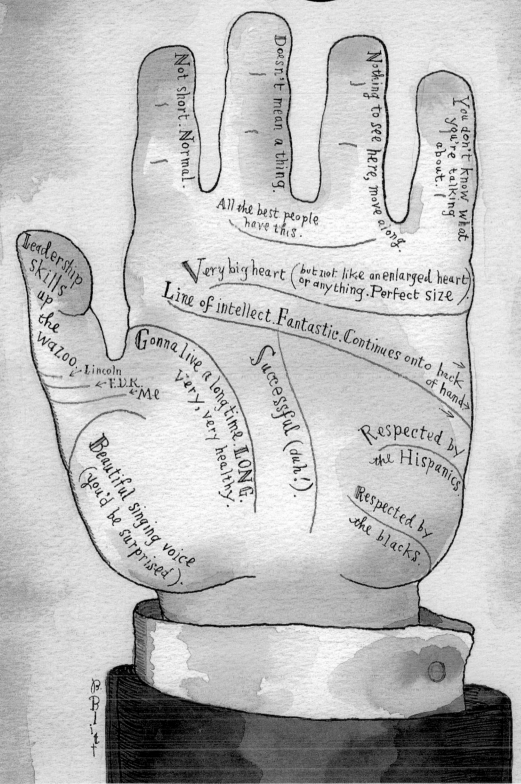

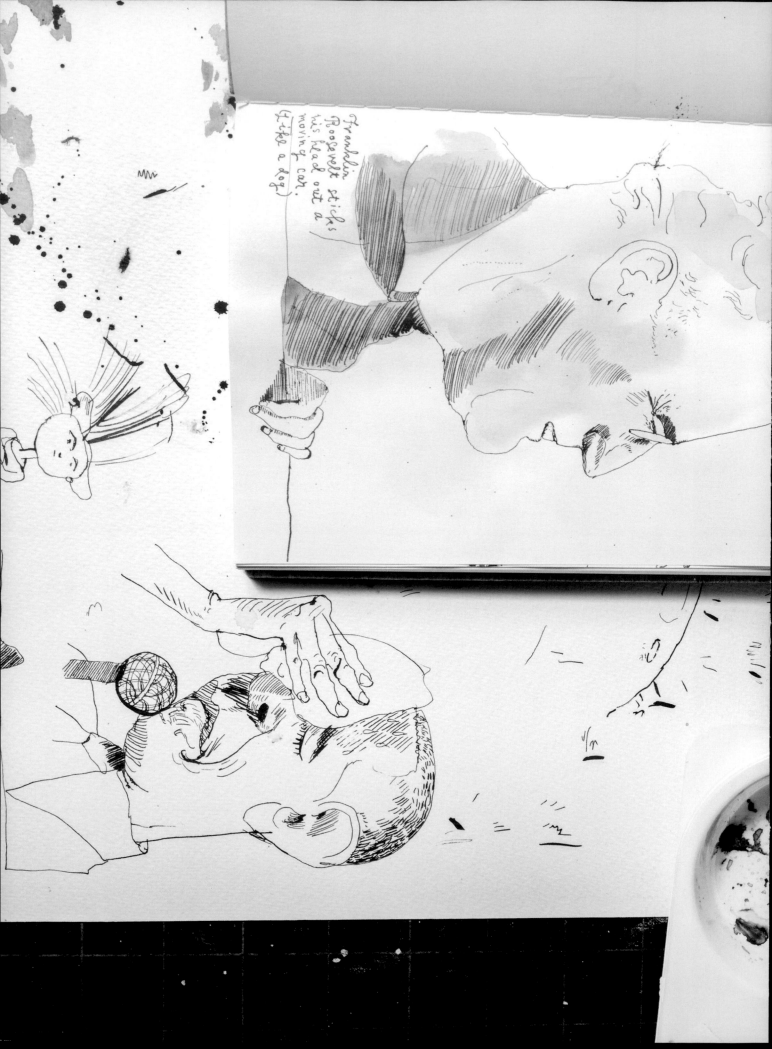

Franklin
Roosevelt sticks
his head out a
moving car.
(like a dog)

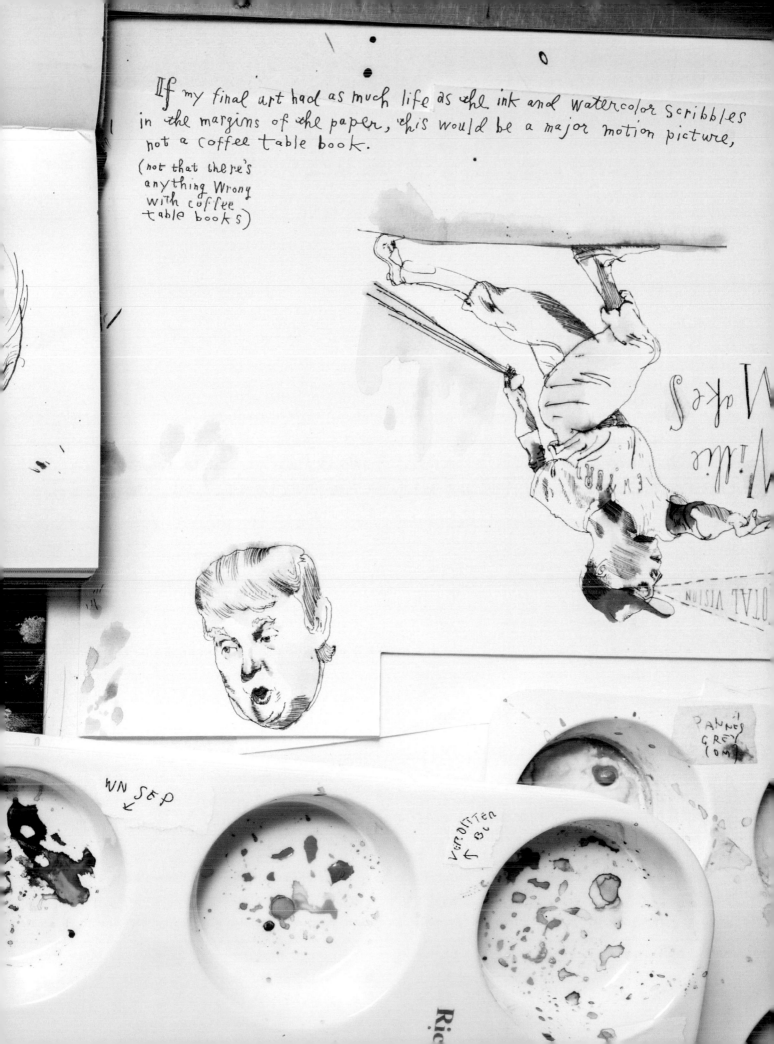

If my final art had as much life as the ink and watercolor scribbles in the margins of the paper, this would be a major motion picture, not a coffee table book.

(not that there's anything Wrong with coffee table books)

not rejected

Barry Blitt's intelligent absurdity, fervent skepticism, and memorable comic imagery are graphically charged detonations against the power brokers, politicians, influence peddlers, and the raging horde of illiberal aggressors who frighten, repress, and besiege us with their false patriotism and greedy corruption. Deploying his disarmingly modest graphic style, his famous (and infamous) *New Yorker* covers have brilliantly attacked more than two decades of folly and hypocrisy. But that is only one part of his collected body of work. He has also produced scores of little-known and less iconic, though no less acerbic, illustrations and cartoons for dozens of publications not principally known for their political content.

Despite appearances, Blitt is not a subversive. Rather, he is an all-around image maker: an illustrator, a cartoonist, and a caricaturist—and an author of his own ideas. He wields his wit for both critique and commentary, but always to trigger a visceral reaction. Wherever his drawings appear, his humor offers a kind of liberation, if only for a moment, from the oppressive news cycles and their perpetual touting of political idiots and ideological idiocy. Blitt's comically incendiary drawings, so effective at precisely piercing the thin skin of the powerful, have garnered him impressive accolades and scorn—often from the same target. There can be no disputing that Blitt has earned a vaulted place in the pantheon of twenty-first-century political satirists, alongside Edward Sorel, Ralph Steadman, Robert Osborn, Jules Feiffer, and Robert Grossman, through output that covertly or overtly defames the unscrupulous and defangs the nefarious.

"I would hope my work is more observational," Blitt once told me. "What could be more boring than partisan satire? I really don't think it makes a difference what my politics are—I'm probably to the left of center on most issues—but in my work I'm looking for ridiculousness and hypocrisy wherever I can find them."

To describe him as only a political artist and provocateur is much too limiting. In an era drowning in digital noise and visual static, it may be more accurate to say that Blitt's virtue is in conceiving pictures that cut through the incomprehensible, that engage his audience with whatever theme he tackles, wherever they are ultimately published.

As his early work reveals, Blitt was not born with a taste for satiric blood. That developed as he realized his drawings mattered to others. I've known him for more than two decades, long enough to recall when his fledgling work was lighter and sketchier and his conceptual self-confidence was more tentative than it is today. In response to a statement I had written that he was one of the most strident

illustrators of the early 2000s, he said with typical cheekiness, "As a small child I drew pictures in my room, dreaming of becoming one of the more comically strident illustrators of the 2000s." He added more seriously, however, that in truth he was "still very tentative, work-wise and everything-wise." While getting published in major magazines throughout the country had to have emboldened him, nonetheless, he told me, "I still have to force myself with every drawing and every sketch to not hold back, to not be too timid on the page."

In his mature work, Blitt does not hold back, but neither does he overplay his cards, picture-wise. Some illustrator-satirists pour their conceptual guts onto the paper. What distinguishes Blitt from his peers is how he uses his loose pen line to outline or contain subtle watercolor hues. As biting as his work may be, its visual appearance is more sublime and soothing—"unthreatening" might be apt—than rabid and raucous. When looking at some of his interpretive observations, like the aviary in a *Men's Journal* cartoon titled "Heading South," I see a curiously original coupling of the fantastical Edward Lear and the trenchant George Grosz—the lyricism of one and the expressionism of the other. It is this well-balanced combination of elegance and power that defines his distinct brand of nuanced irony.

Once, in a conversation we had, Blitt implied that much of his best work was the result of accidents that somehow succeeded. I don't believe that for a minute. A visual satirist is incapable of hitting as many bull's-eyes as Blitt has done without being disciplined. While accidents obviously happen, discipline is knowing when and how to capitalize on them—it takes mastery to use opportunity. What looks ad hoc cannot really be ad hoc. Arguably, line for line, brushstroke for brushstroke, Blitt has hit his moving targets as often as or more often than comparable name-brand artists for years and his hit rate does not rely entirely on the comic drawing virtues of his pictures alone.

Blitt's effectiveness as a topical commentator is his virtuosity with words and pictures. Both components are consistently in sync in his work, regardless of how simple the words. Take "All I Want for Christmas: Young Elites and Their Holiday Wishes," created during the Bush era. What could be funnier or, for that matter, more disarming than a defanged "Billy O'Reilly" or "Lil Hillary Clinton" posing cutely and lisping their sincerest wishes? Blitt's wit comes through simply in the title "Rejected New Nicknames for Sean 'Puff Daddy' Combs (or Whatever He's Calling Himself Now)." And when it comes to absurd reality, the off-the-wall comedy of "Cellular Phones of the Future," notably the "Talk 'n' Shoot" cellphone-and-pistol combo, is spot-on hilarity. His word-and-picture conceptual combos are one-two punches to the head.

During World War II, Germany ravaged its foes through blitzkrieg, lightning bombardments on defenseless cities. Blitt's keen satirical ability, though not as lethal, might qualify as a sort of "Blittskrieg." He possesses the ability to devastate his targets with a single image and leave the rest of us smiling. Viva Blitt. May Blittskrieg continue. —Steven Heller

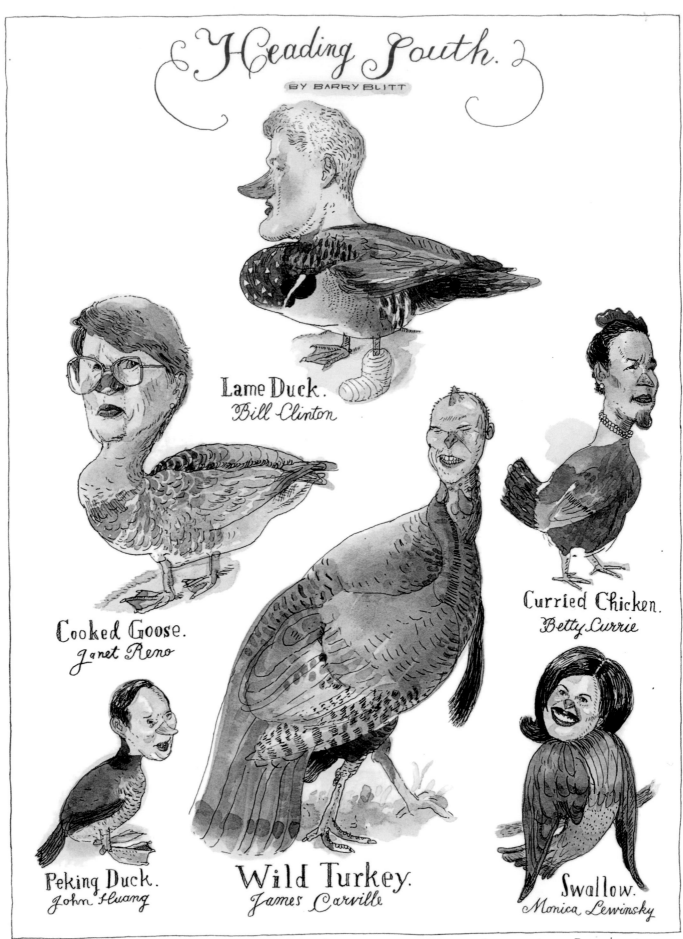

Heading South.
BY BARRY BLITT

Lame Duck.
Bill Clinton

Cooked Goose.
Janet Reno

Curried Chicken.
Betty Currie

Peking Duck.
John Huang

Wild Turkey.
James Carville

Swallow.
Monica Lewinsky

If I admit that this entire cartoon was just an excuse to draw Miss Lewinsky as a swallow, will that speak ill of me?

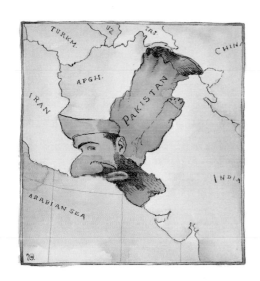

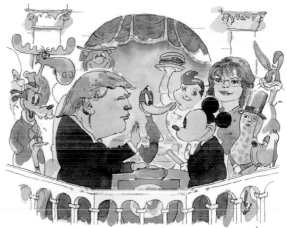

This illustration was published long before the situation depicted seemed even comically possible

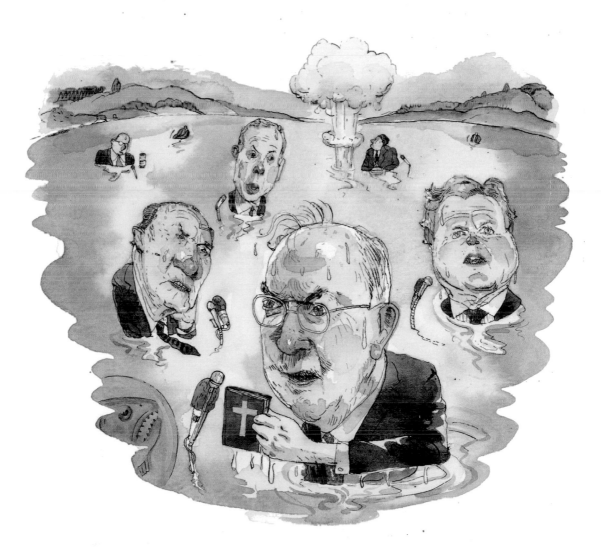

Opposite page: Heading South, *Men's Journal,* 2000

Top left: From Abbottabad to Worse, *Vanity Fair,* July 2011; *Top right:* Losers,
Vanity Fair, November 2015; *Above:* Untitled, *Mother Jones*

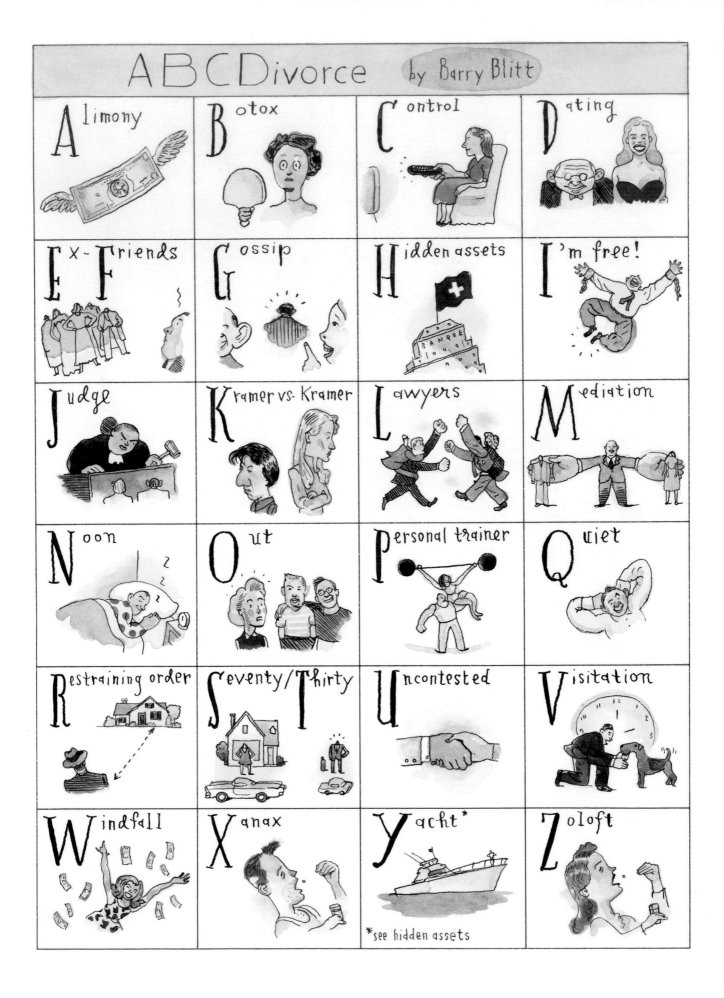

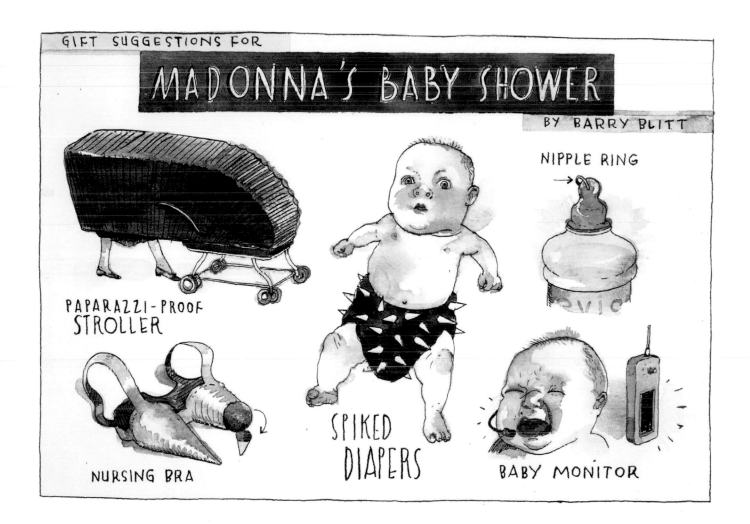

Above: Madonna's Baby Shower, *Entertainment Weekly*, April 26, 1996

Opposite page: ABC Divorce, *Los Angeles Magazine*

A couple of cartoons from the 1990s, before
W. Bush or Trump or even Drudge...

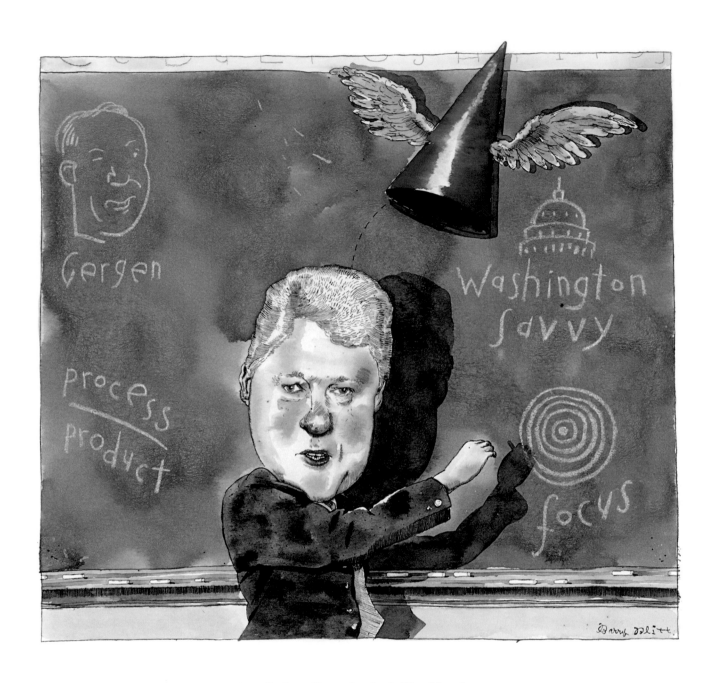

Above: Professor Clinton, *Los Angeles Times Magazine*

Opposite page: All I Want for Christmas: Young Elites and Their Holiday Wishes,
The Washington Post, November 23, 2006

All I Want For Christmas

YOUNG ELITES AND THEIR HOLIDAY WISHES

By B. Blitt

I WANT A NEW SCOOTER.

Dickie Cheney

I AGREE WITH THE 63% OF GIRLS MY AGE WHO WOULD LIKE A PONY (AS OPPOSED TO THE 22% WHO REQUESTED A BARBIE DOLL AND 15% WHO DIDN'T KNOW).

Li'l Hillary Clinton

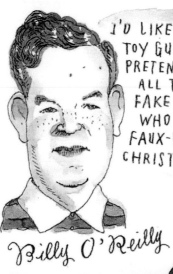

I'D LIKE A TOY GUN, TO PRETEND-SHOOT ALL THE FAKE PEOPLE WHO ARE FAUX-KILLING CHRISTMAS!

Billy O'Reilly

I WANT A DOG!

Ricky Santorum

TWO MILNES, THREE ROWLINGS, AND ANYTHING BY BABAR.

Georgie Bush

I JUST WANNA BE ALLOWED OUT OF MY ROOM TO PLAY COWBOYS AND INDIANS.

Jackie Abramoff

I LEARNED A LONG TIME AGO THAT YOU GO WITH THE CHRISTMAS PRESENTS YOU GET, NOT THE CHRISTMAS PRESENTS YOU WANT.

Donny Rumsfeld

Depicting the inner child (and outer child) of several Washington insiders

I'm still not certain who this fellow is, or what it is he does

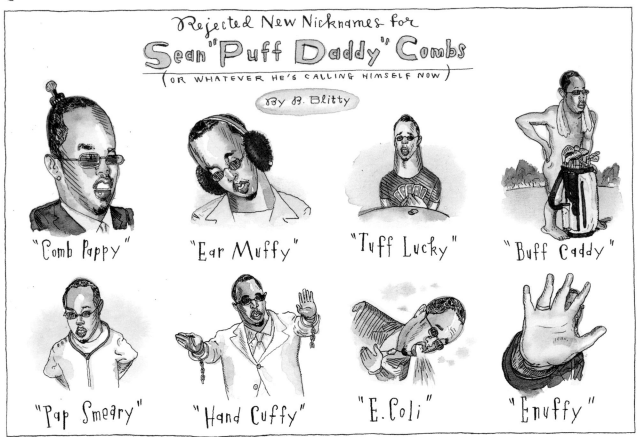

Above: Rejected Nicknames for Sean "Puff Daddy" Combs, *Entertainment Weekly*

Opposite page: Strictly Looney Toons, or:
I Tot I Taw a Coup d'Etat!, *Mother Jones*, January/February 2003

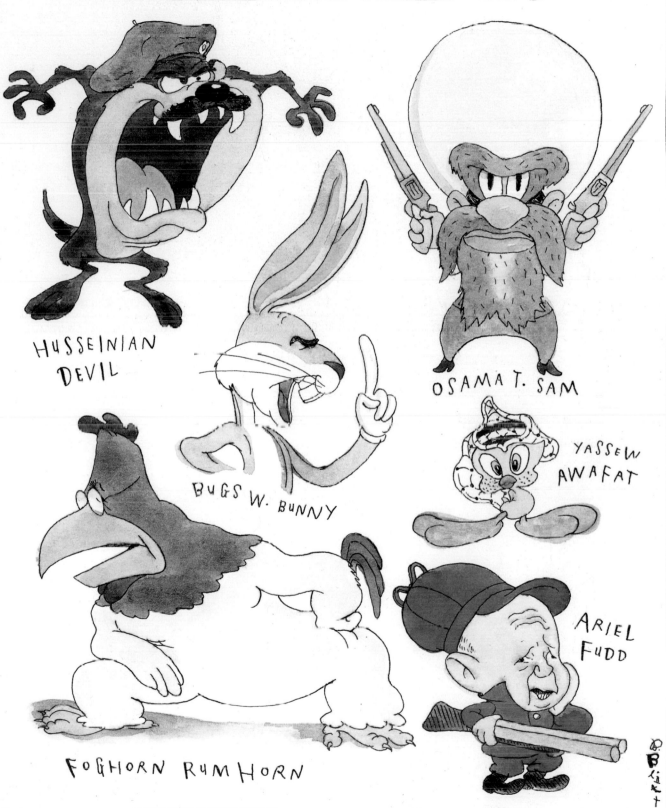

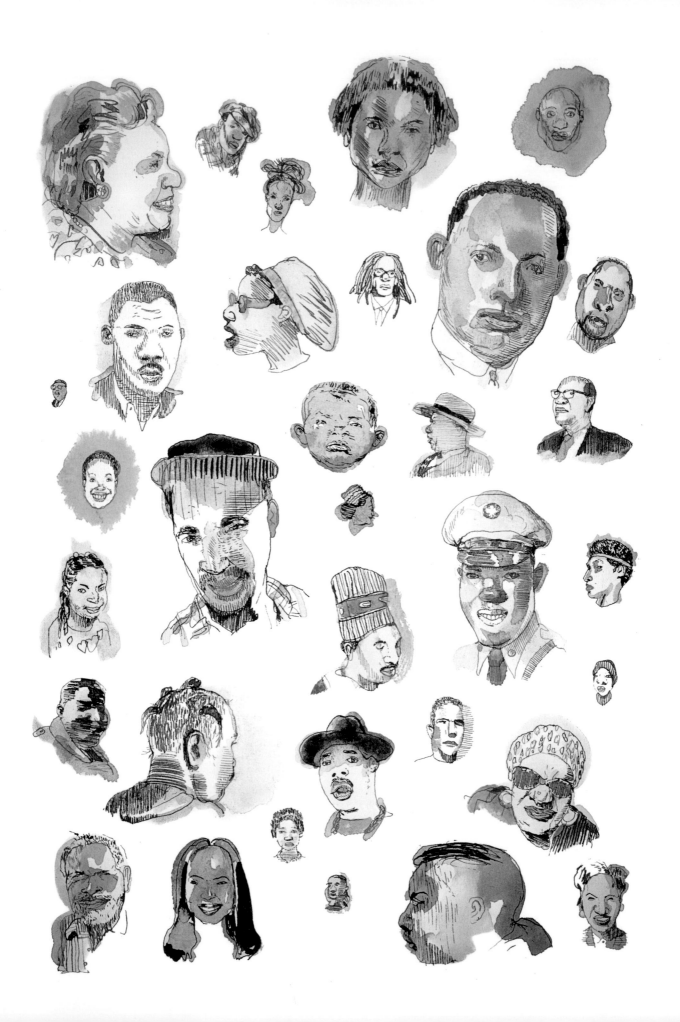

Opposite page: Lifting Every Voice, *The Boston Globe*, February 14, 1999

Above: Publication Unknown

As the caption suggests, I can't remember when, why, or for whom I did this illustration (maybe it isn't even one of mine)

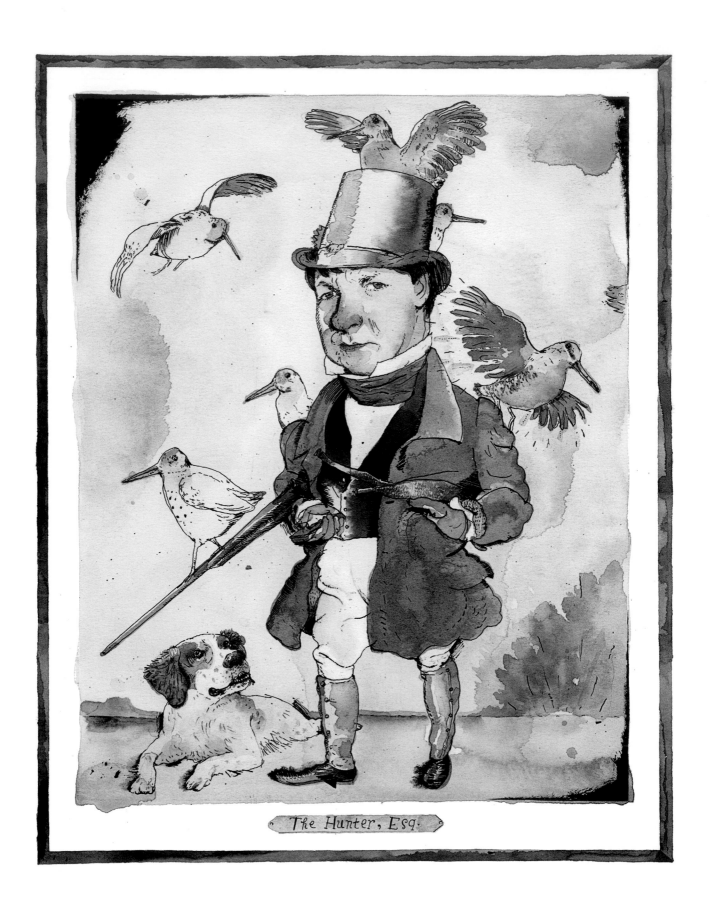

The Hunter, Esq.

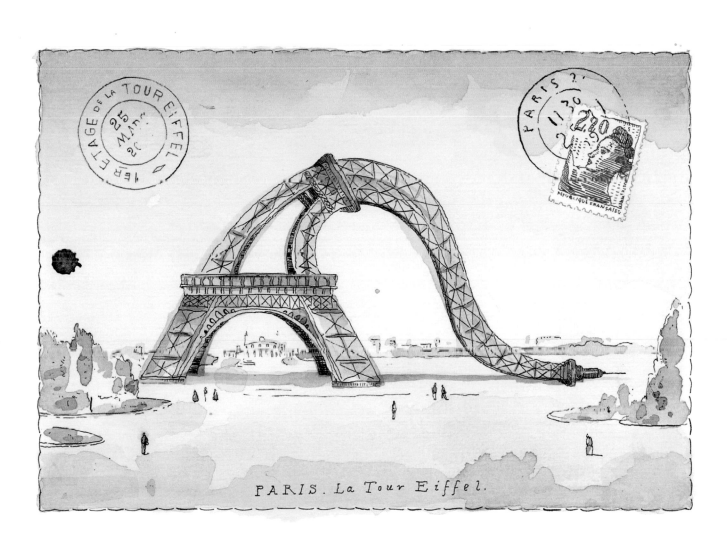

Opposite page: The writer P. J. O'Rourke as The Hunter, Esq., *Men's Journal*

Above: Liberté, Egalité, Fatigué, *Vanity Fair*, April 2014

Picture book idea: "Flaccidity in Public Monuments"
(could be a hit with the late baby boomer generation)

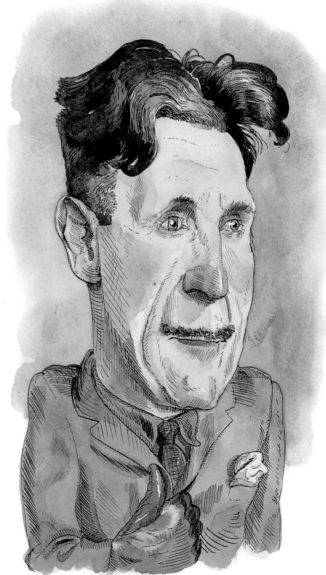

I Still Like Ike

It took me like three hours to finish the shading on George Orwell's upper lip

136

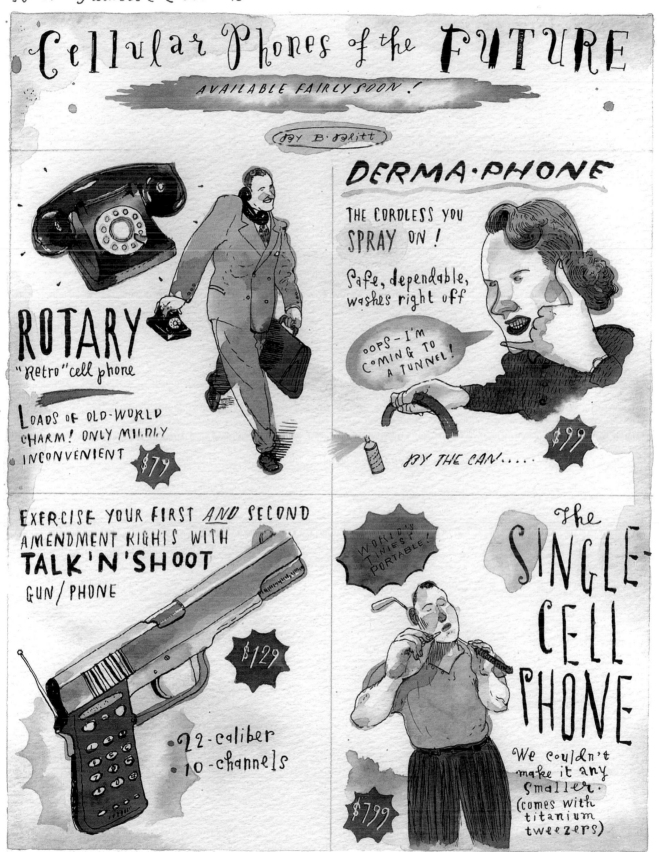

Mark Twain sure is fun to draw (his mustache will live on so long after his eyebrows are gone)

Above: From *The Adventures of Mark Twain by Huckleberry Finn*, Atheneum, 2011

Opposite page: White Is the New Black (What's New This Season),
Publication unknown

White is the New Black

(What's new this season)

Square is the new round

Dull is the new vibrant

Middle age is the new young

Damp is the new moist

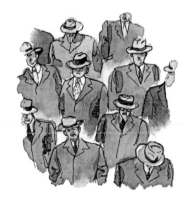

Average is the new extreme

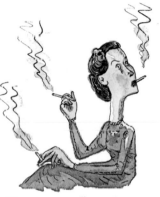

Jumpy is the new calm

Tepid is the new cool

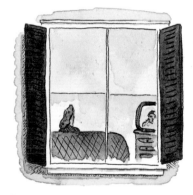

Staying in is the new going out

Falling down is the new standing up

Dull is the new vivid, that's for certain

This was drawn shortly after Mike Tyson bit off part of Evander Holyfield's ear. (don't be alarmed, it occurred during a boxing match)

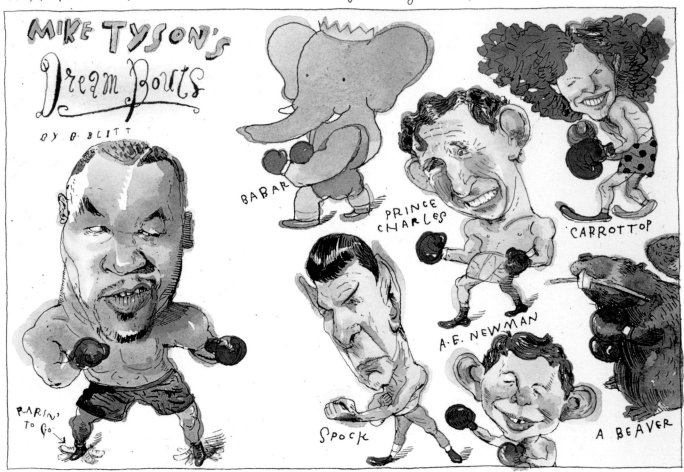

Above: Mike Tyson's Dream Bouts, *Entertainment Weekly*

Opposite page, top to bottom: Illustration for "The End of the Year as We Know It," *Vanity Fair,* December 2010; Early Effects of El Niño on the Industry, *Entertainment Weekly*

Spots of Sarah Palin (and her people) on covers of publications she can't recall

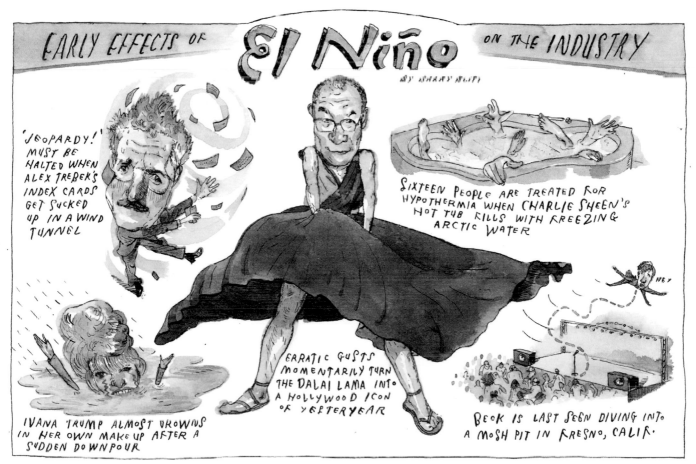

EARLY EFFECTS OF El Niño ON THE INDUSTRY

'JEOPARDY!' MUST BE HALTED WHEN ALEX TREBEK'S INDEX CARDS GET SUCKED UP IN A WIND TUNNEL

SIXTEEN PEOPLE ARE TREATED FOR HYPOTHERMIA WHEN CHARLIE SHEEN'S HOT TUB FILLS WITH FREEZING ARCTIC WATER

HEY

IVANA TRUMP ALMOST DROWNS IN HER OWN MAKEUP AFTER A SUDDEN DOWNPOUR

ERRATIC GUSTS MOMENTARILY TURN THE DALAI LAMA INTO A HOLLYWOOD ICON OF YESTERYEAR

BECK IS LAST SEEN DIVING INTO A MOSH PIT IN FRESNO, CALIF.

Covering Climate for Entertainment Weekly

A drawing about Safe Sex from the 1980s

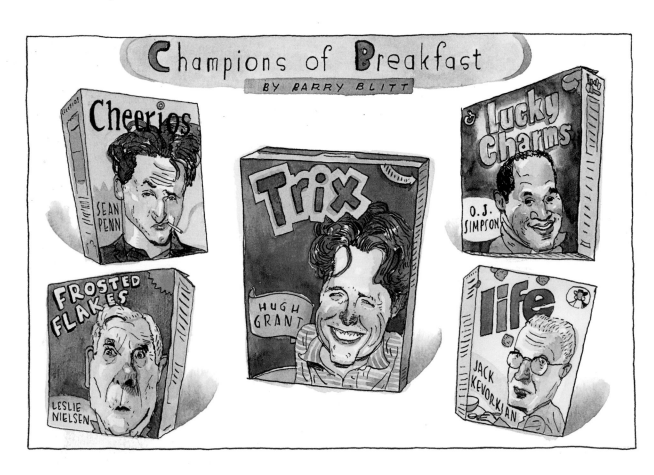

Opposite page, top to bottom: Safe Sex, *Toronto Life Magazine*; Champions of Breakfast, *Entertainment Weekly*, August 16, 1996

Above: Publication unknown

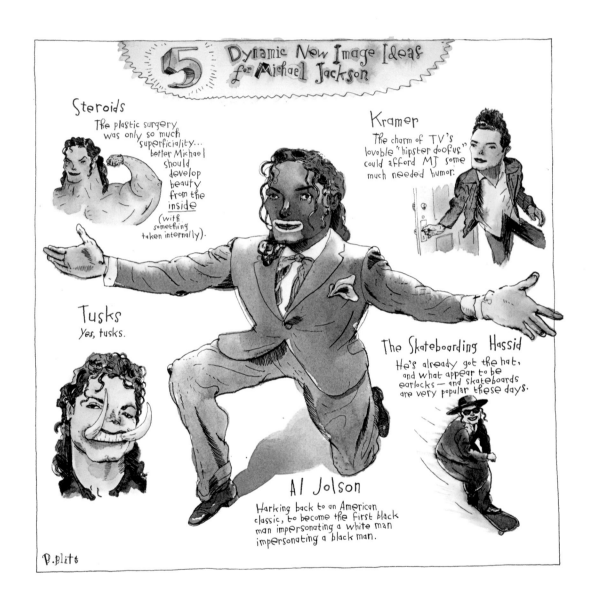

Above: 5 Dynamic New Image Ideas for Michael Jackson, *Entertainment Weekly*, June 16, 1995

Opposite page: Two Dogs Tied to the Top of Romney's Ark, *Vanity Fair*, August 2012

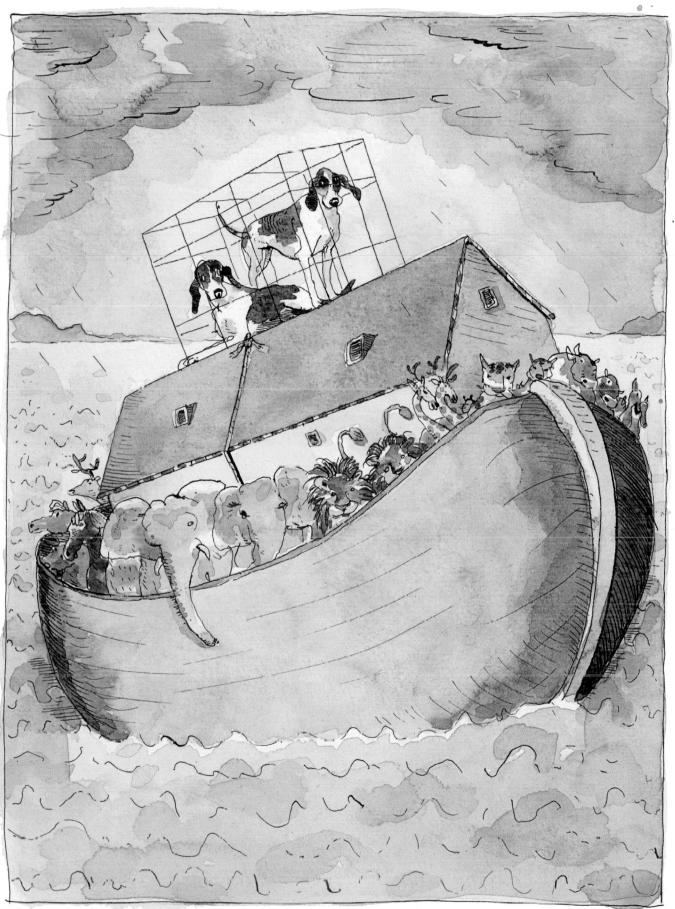

When Mitt Romney recalled how his family vacations ~~in~~ involved strapping the dog's crate (with dog inside) to the roof of the car, the sarcasm industry took notice

My palette — where color goes to die.

Crazy ideas

Barry Blitt is one of the few artists I work with who make me laugh. As the art editor of *The New Yorker*, I am in constant contact with some of the funniest artists around, but once David Remnick, the magazine's editor, has weighed in on their ideas, the phone calls can be hard to make. Most often I have to deliver the bad news on the many, many propositions that will not be used. The pleasure in dealing with Barry is that he sends a lot of sketches and he's not precious about them. "TOO MUCH? TOO LITTLE? TOO LATE?" he scribbled in one of the cheerful notes that accompany his batches.

So I look forward to calling Barry regardless of what I have to convey. We'll chat and exchange pleasantries, and out of the blue he'll make me burst out laughing. Most often his humor is at his own expense: he may mention his loathing for any kind of heat or good weather (he grew up in Montreal), or tell me how dismal his piano playing at the Society of Illustrators was (a regular gig for him and a few friends), or qualify the bucolic setting in Connecticut where he lives with his wife, Angie (they bought Henry Miller's house), as "twee." Barry may be one of our most accomplished and prolific artists, but you wouldn't know it from talking to him. He is genuinely modest. The only reservation I have about writing these lines is knowing how he will cringe reading them—but voilà, the cat is out of the bag. Barry is a fearless taboo-breaker for whom the greatest sin is that of pride.

I met Barry more than twenty years ago. My first impression was that he was cry-out-loud funny and hugely talented yet timid. He came to *The New Yorker's* office to show me some cartoons—a few panels on a page about a beard museum, if I recall correctly. I immediately loved the wit that suffused his quirky and recognizable handwritten captions. The contrast between the sharp content and the delicate drawings done with an old-fashioned crow quill pen dipped in India ink and a light watercolor wash seemed a perfect fit for *The New Yorker*. Always desperate for artists who are funny and can draw well, I jumped at the chance to ask Barry to try his hand at a cover. We had just talked about the sight of New York City smokers clustering in front of office buildings as indoor smoking bans went into effect.

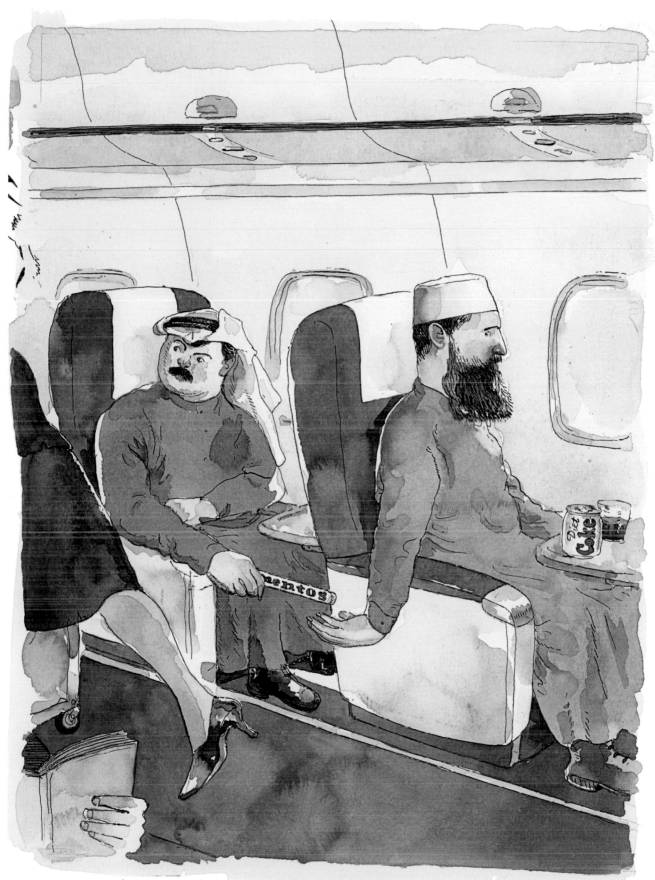

If you have young children (or just enjoy the company of eleven-year-olds), you know all about Mentos & Diet Coke.

Unused sketch for *The New Yorker*

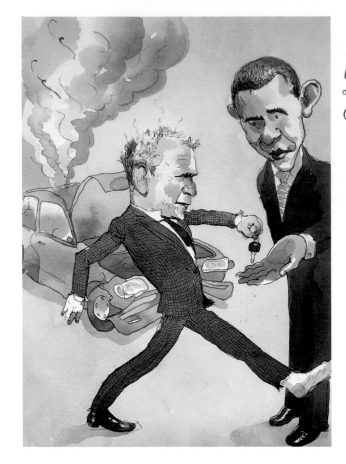

Someone thought this drawing of ex-president Bush handing the car keys over to president-elect Obama made him (Obama) look like a valet, and the whole thing was scrapped

Abandoned *New Yorker* cover art

In sketches by other artists, the humor was in the exaggerated clouds of smoke. Barry came up with a unique take: his smokers were indeed outside throughout the city, but they were suicidal loners perched on window ledges—smoking as an antisocial act of lunacy. So the Blitt cover was born: an image in which quaint style and sharp wit blend to prod you to keep looking past the first chuckle. His covers make lasting impressions once the reader unfolds all the layers of meaning.

I have come to rely on calling Barry often. I ask him for sketches, and he always sends a few—at least three or four, usable or not. It's part of the deal that he doesn't edit out the gross, the vulgar, the outré, the unpublishable. A humorist like Blitt is often referred to as having an edge—and to find that edge, he has to go beyond it, sometimes far beyond. The thrill in looking at Barry's images is often not so much in what he shows but in what he doesn't. There's more than meets the eye, but he makes the reader fill in the gap. About his portrayal of Tiger Woods for a cover he submitted when a seemingly endless stream of mistresses was uncovered (the *National Enquirer* claimed Woods had slept with more than 121 different women in his six years of marriage), Blitt said: "Woods's whole thing was that he was so wholesome, a clean young man who sponsored many products. You just didn't think of him doing something like

this. . . . You really have to have some remove from the tabloidness of a story like this, otherwise it wouldn't seem *New Yorker*-y. To see him in bed with a whole bunch of women, that wouldn't work."

Depending on what day of the week I call Barry, he may have only a few hours to respond, and once an idea is picked, he'll often have less than a day to draw and paint the finish. Barry will often do more than one finish, working hard so that each version appears casual and loose. If there's a single part that he doesn't like, he redoes the entire picture. And yet the sense of spontaneity that he is able to preserve adds to the humor. It gives you the feeling that the artist had such a great idea he couldn't wait to show it to you.

Paying attention to small details, Blitt manages to make points about big issues. When we were discussing his sketch of Trump as Miss Universe, for example, I noted that the fact-checkers had queried the kind of bathing suit he had dressed the contender in. Pageants under Trump's ownership have become more openly sexualized, with contestants wearing bikinis rather than one-piece suits. Barry knew that, but he wanted the Donald to wear an old-fashioned tiara and suit. He wanted to depict the great old days of women being objectified on runways implicit in Trump's slogan "Make America Great Again." "I wish I was working on a larger scale, and righting wrongs and pointing out injustices, but really my tools are looking for absurdities and finding ridiculousness and making myself laugh," he said in an interview.

It seems fitting that it takes a Canadian to teach me, another foreigner, the quirks of American culture. Barry, who grew up in a Jewish neighborhood in Montreal, is very patient about explaining to a Frenchwoman what exactly Larry, Moe, and Curly contribute to the culture. Early on, he had me tune in to Fox News rather than MSNBC, and he has probably spent more time listening to Rush Limbaugh than anyone else I know. And in an era of segmented narrow-interest news, there's great value in having an artist who insists on being a "nothing is sacred" opportunist. Blitt has mocked the pope and Michael Jackson, yet what he targets most acutely are our own most hidden prejudices. And because he doesn't exempt himself, his discourse is more that of a humanist than a misanthrope. He readily acknowledges that he's just as fallible as the rest of us—or more so, he'd probably say. When he took on the Diet Coke and Mentos meme in 2005, he first tried his idea with two children and then two businessmen before finding the right and frightfully funny combination—two Arab men. All the versions made fun of terrorism, but only the last version made fun of our own fears.

When I talked to Barry recently about writing this piece, I told him again how grateful I am for the trust we have built together and how much I appreciate that he doesn't extract too high a price when it comes to rejection. His sincere response came instantly: "Are you kidding? I love rejection! There's nothing more painful than having a cover run—that's when you have to live with all the imperfections." —Françoise Mouly

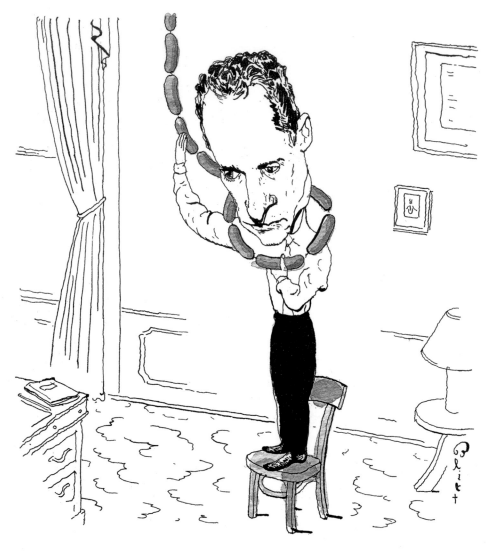

Anthony Weiner (D-NY)

Above: Cartoon for *The New Yorker* (killed at the last minute)

Opposite page: Untitled, ill-fated *New Yorker* cover sketch

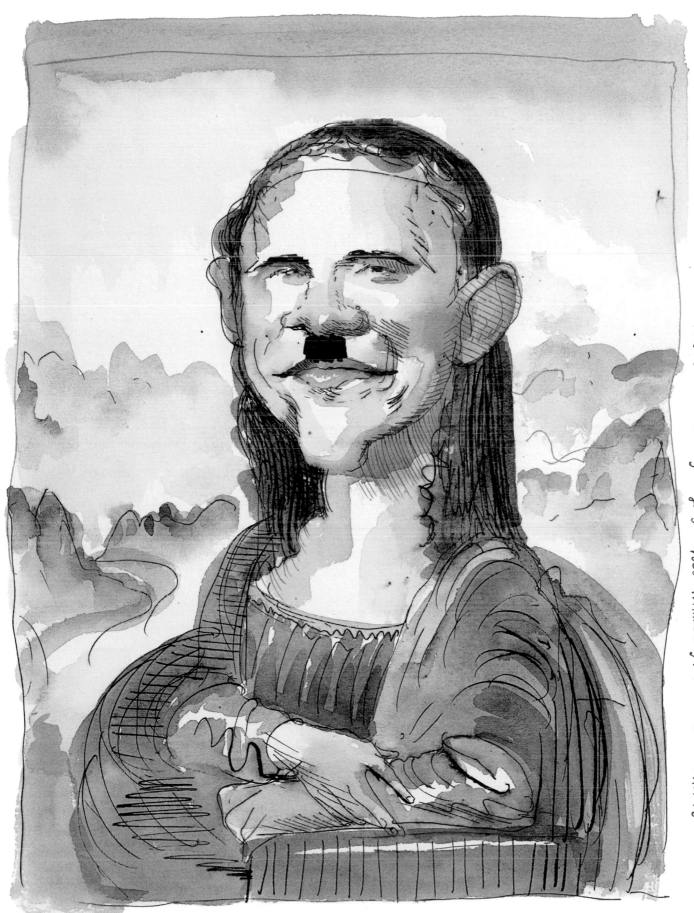

I believe magic mushrooms were involved in the crafting of this winner from the archives

Untitled, abandoned
New Yorker sketch

Suddenly seemed preposterous
(more than usual, I mean)
about halfway through

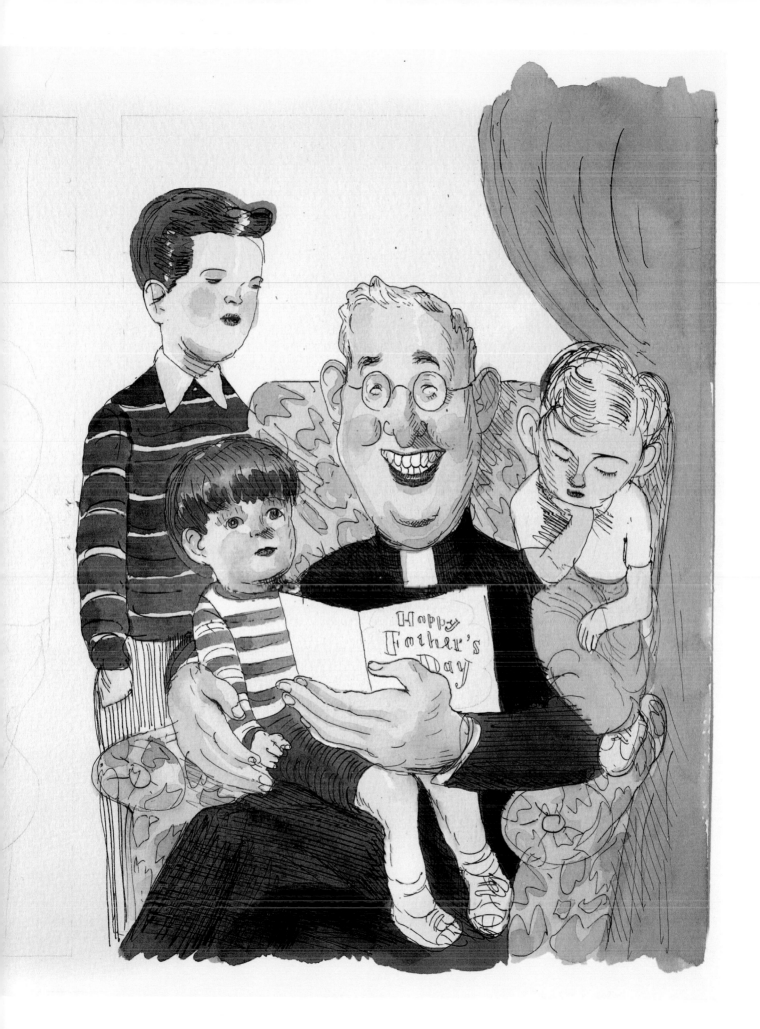

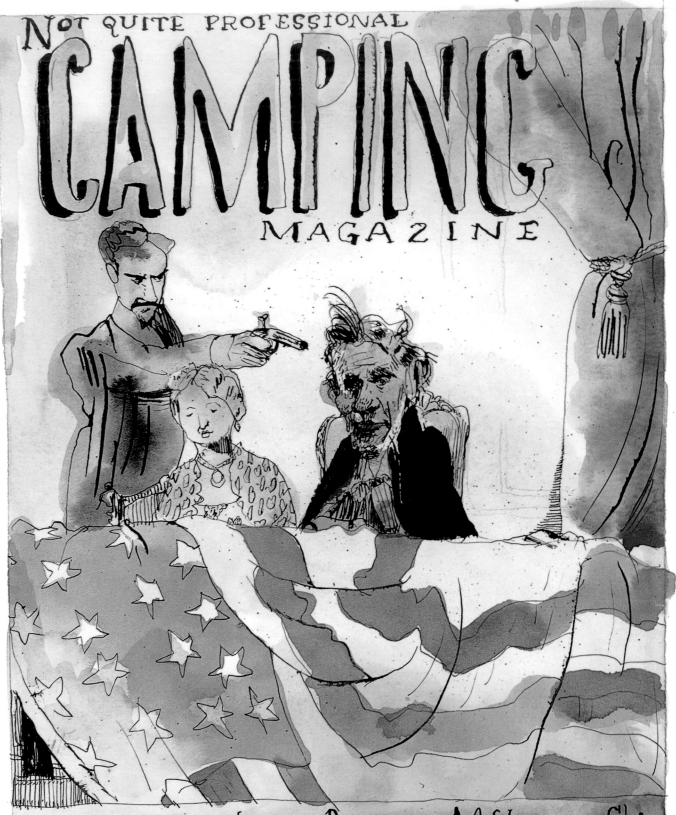

No other magazine captured the collective american imagination in the middle 1950's

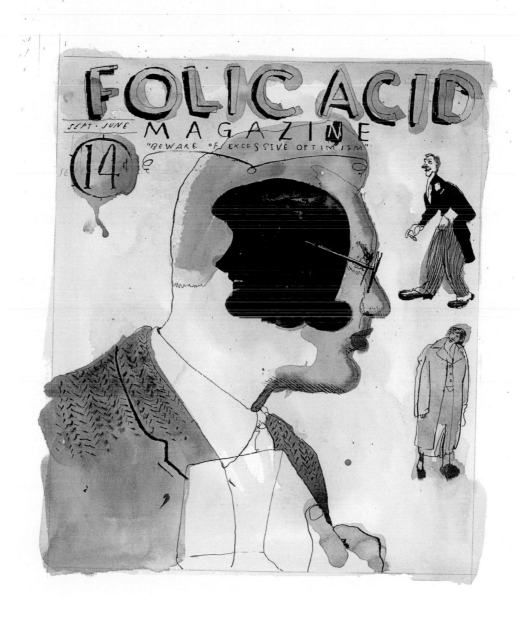

Untitled color sketches

Sort of hard to explain (even to myself)

puzzled about the origin and/or point of these

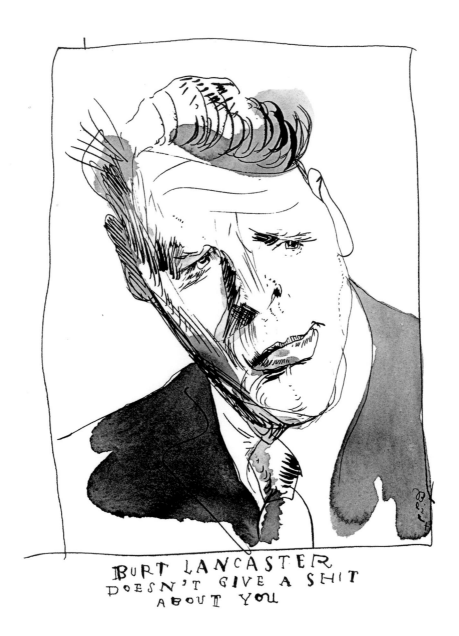

BURT LANCASTER DOESN'T GIVE A SHIT ABOUT YOU

Above and opposite: Untitled sketches with varying amounts of color (as if that helps)

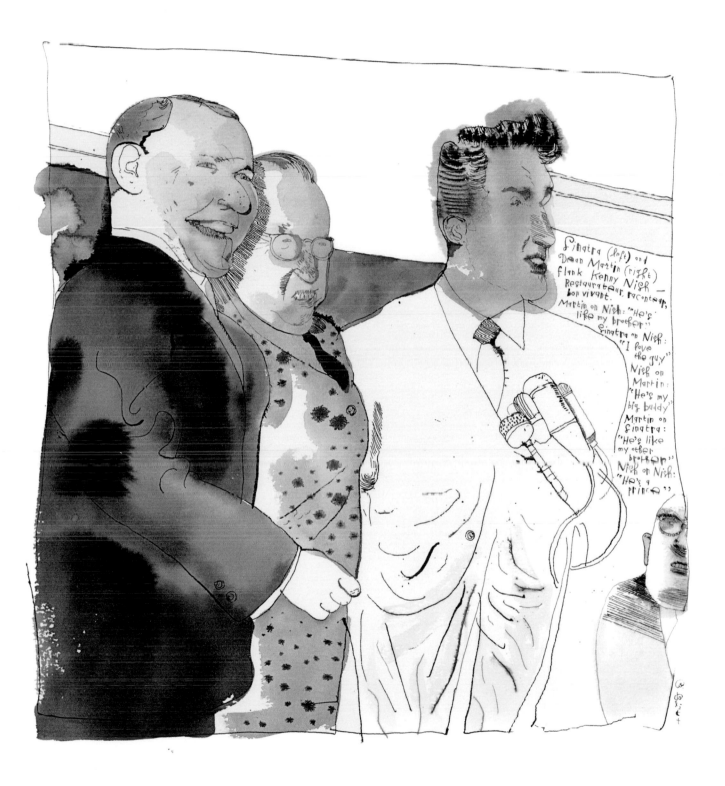

Sinatra (left) and Dean Martin (right) flank Kenny Nish — Restaurateur, raconteur, bon vivant.
Martin on Nish: "He's like my brother"
Sinatra on Nish: "I love the guy"
Nish on Martin: "He's my big buddy"
Martin on Sinatra: "He's like my other brother"
Nish on Nish: "He's a prince"

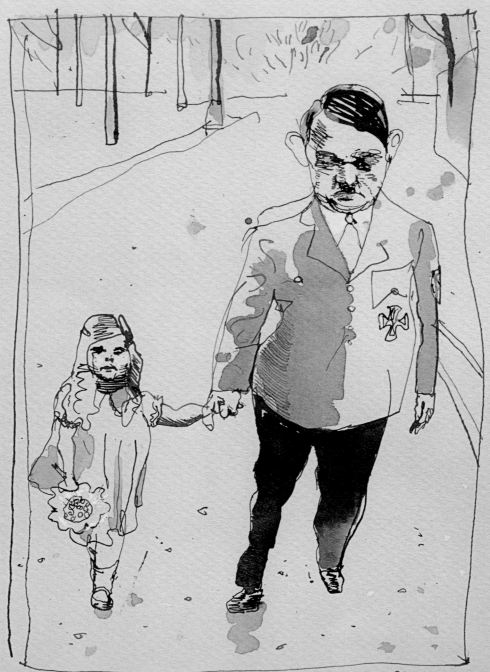

Adolf Hitler with his beloved niece, Clara Schütz. "The whole thing was her idea," he often said.

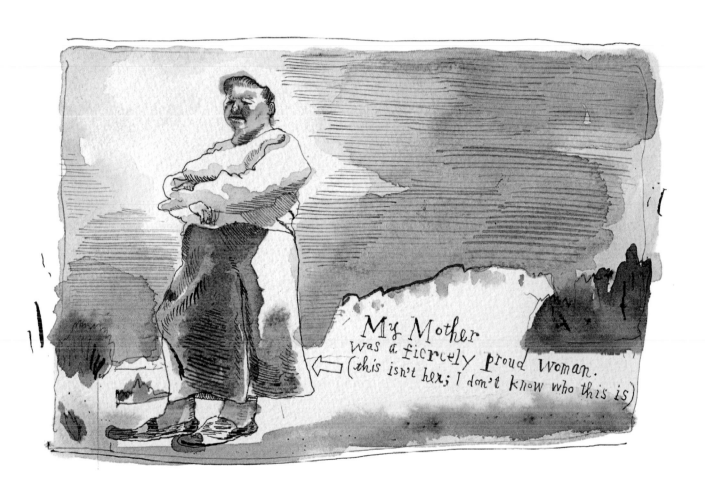

The text within the sketch reads:

My Mother was a fiercely proud woman.
(this isn't her; I don't know who this is)

Opposite page: Untitled Hitler sketch, 2015

Above: Untitled mother sketch

This cheeky image was accepted and then rejected by *The New Yorker*, then subsequently accepted and killed by *Vanity Fair*, and then rejected by *The Huffington Post*. (This is what's known in illustration circles as a "triple bogey")

Above: Unpublished Tiger Woods drawing

Opposite: Babe Ruth sketchbook page

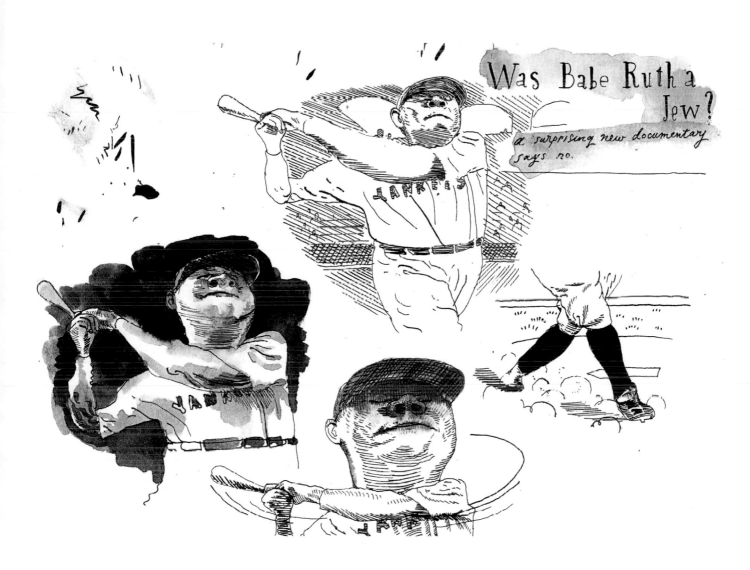

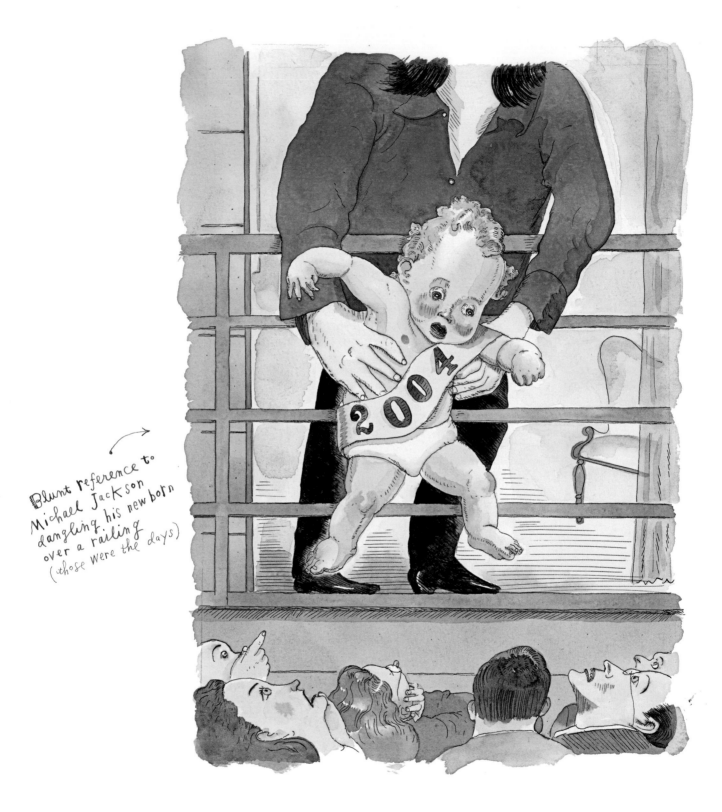

Blunt reference to Michael Jackson dangling his newborn over a railing (those were the days)

Above: Untitled New Year's cover attempt for *The New Yorker*, 2004

Opposite page: Untitled Ratzinger-as-Marilyn-Monroe idea, about the latest in a series of Catholic Church scandals

Next page: Pen and ink and watercolor drawings on postcards, drawn on the spot in various locations, back when I used to leave the house (the late 1990s, I think)

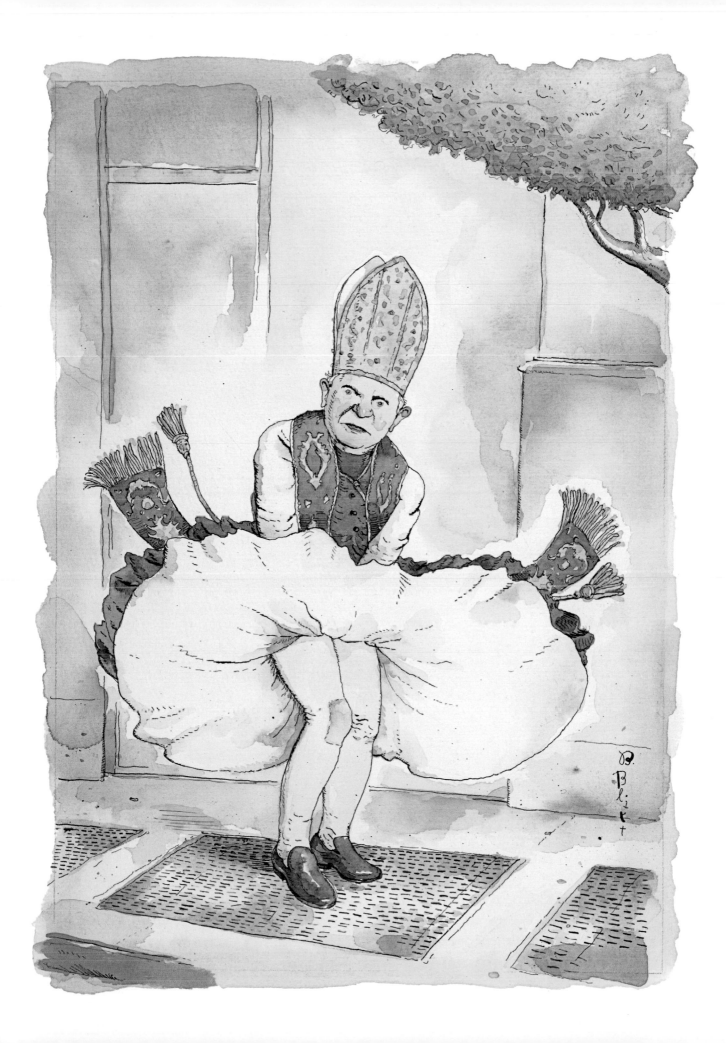

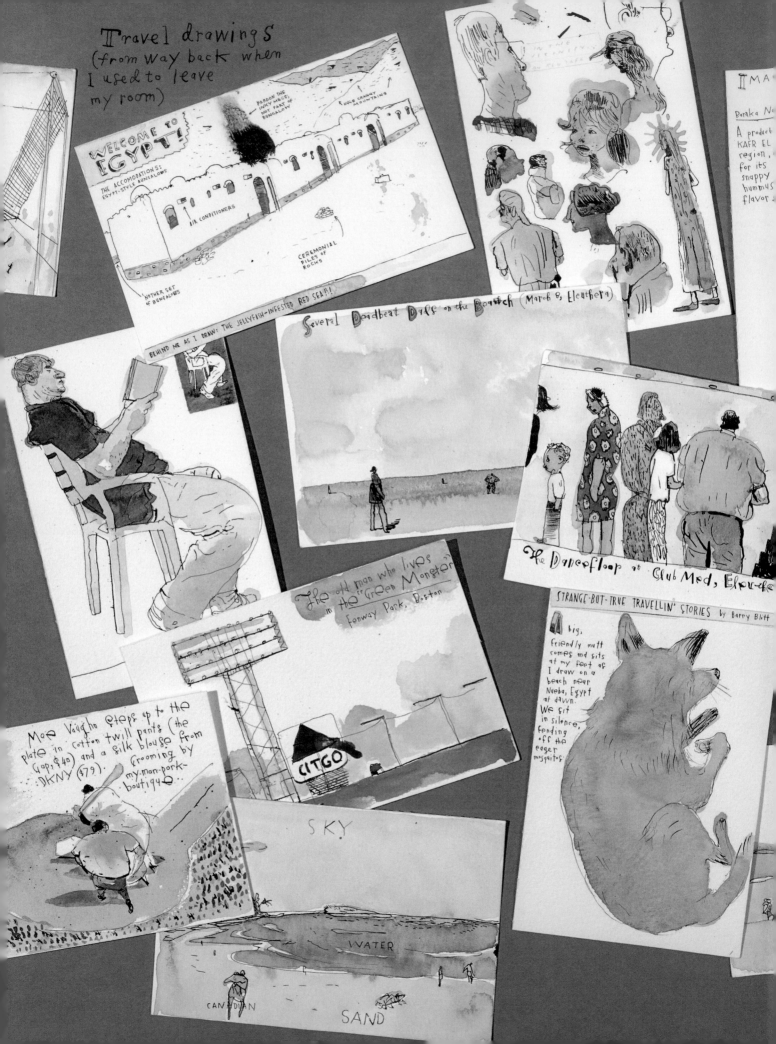

Travel drawings
(from way back when
I used to leave
my room)

WELCOME TO EGYPT!
THE ACCOMODATIONS: EGYPT-STYLE BUNGALOWS
PARDON THE INKY MESS: NOT PART OF BUNGALOW
HUGE CRAGGY MOUNTAINS
AIR CONDITIONERS
CEREMONIAL PILES OF ROCKS
NOTHER SET OF BUNGALOWS

BEHIND ME AS I DRAW: THE JELLYFISH-INFESTED RED SEA!!!

IN THE VICINITY... AN OLD CAFE

IMA...

Baraka No...

A product KAFR EL region, for its snappy hummus flavor...

Several Deadbeat Dads on the Beach (March 8, Eleuthera)

The Dancefloor at Club Med, Eleu-the...

The old man who lives in the "Green Monster"
Fenway Park, Boston

CITGO

STRANGE-BUT-TRUE TRAVELLIN' STORIES by Barry Blitt

A big, friendly mutt comes and sits at my feet as I draw on a beach near Nueba, Egypt at dawn. We sit in silence, fending off the eager mosquitos.

Moe Vaughn steps up to the plate in cotton twill pants (the Gap, $40) and a silk blouse from DKNY ($79). Grooming by my-man-pork-bout1940.

SKY

WATER

CANADIAN

SAND

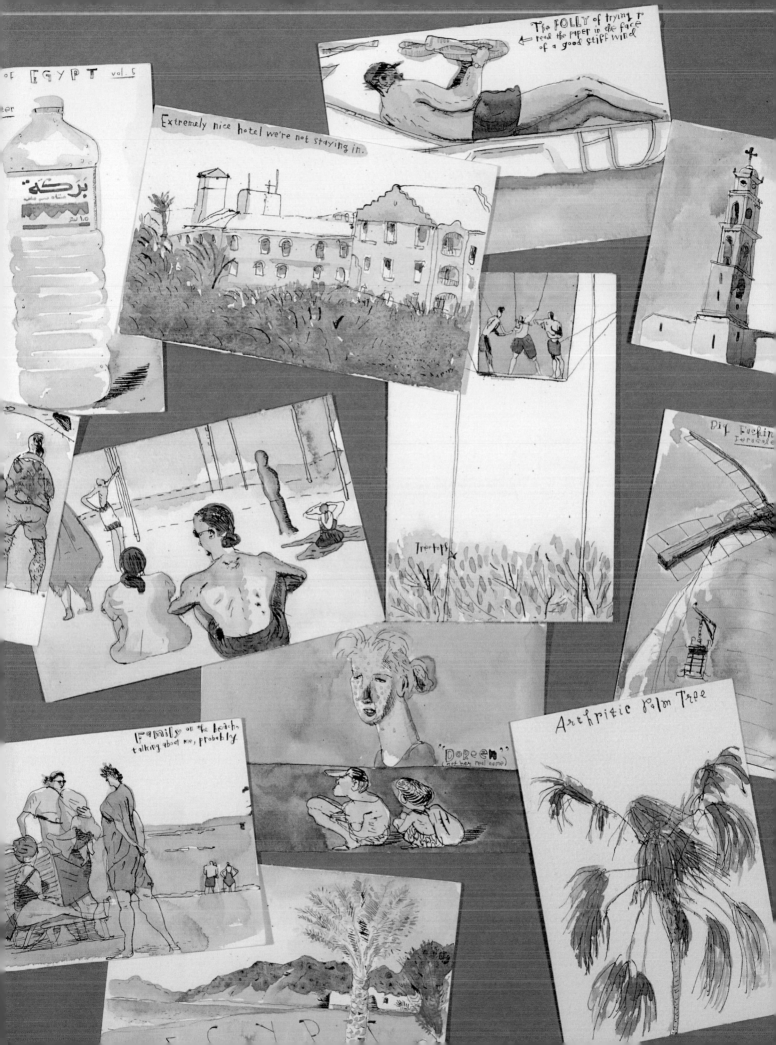

The FOLLY of trying to read the paper in the face of a good stiff wind

Extremely nice hotel we're not staying in.

Treetops

Dig Fuckin Furocale

Arthritic Palm Tree

Family on the beach, talking about me, probably

"Doreen" (not her real name)

EGYPT

Rudolph the Energy Efficient Reindeer

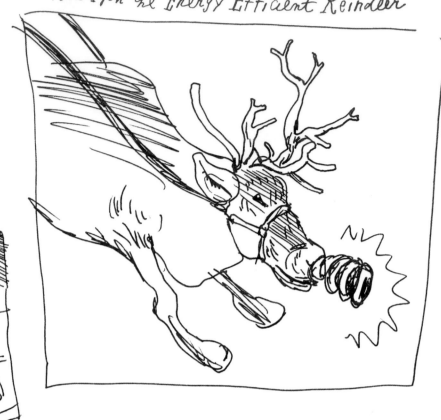

"A Very Isis Christmas"
(sketches shown to no one)
(please keep them to yourself)

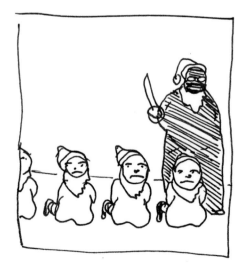

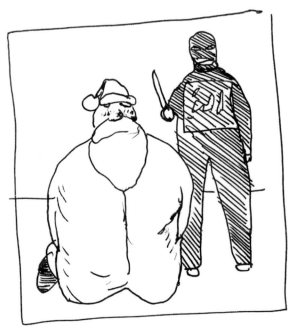

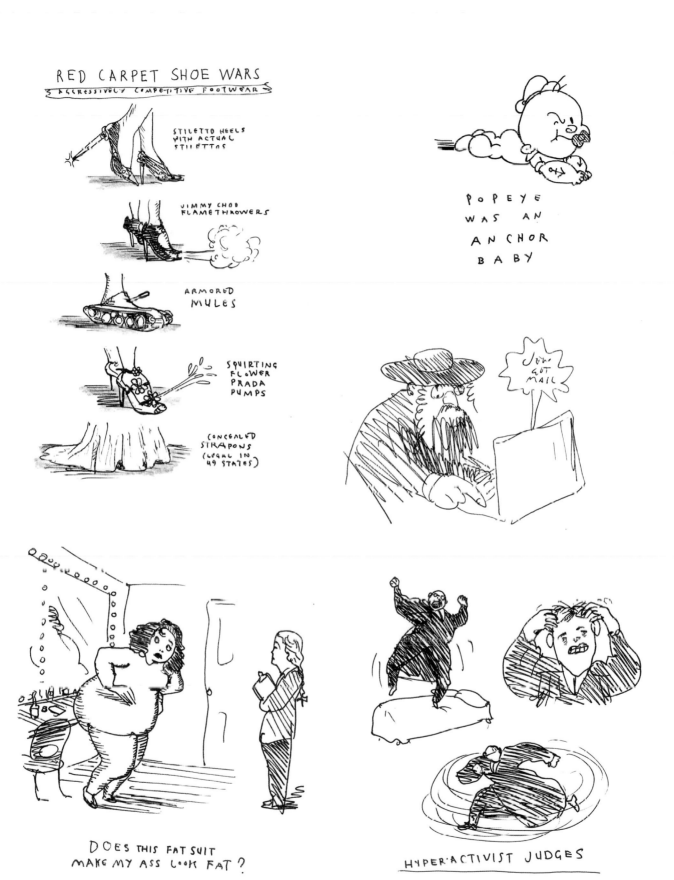

Page of nonsense from several sketchbooks in the early
twenty-first century (or thereabouts)

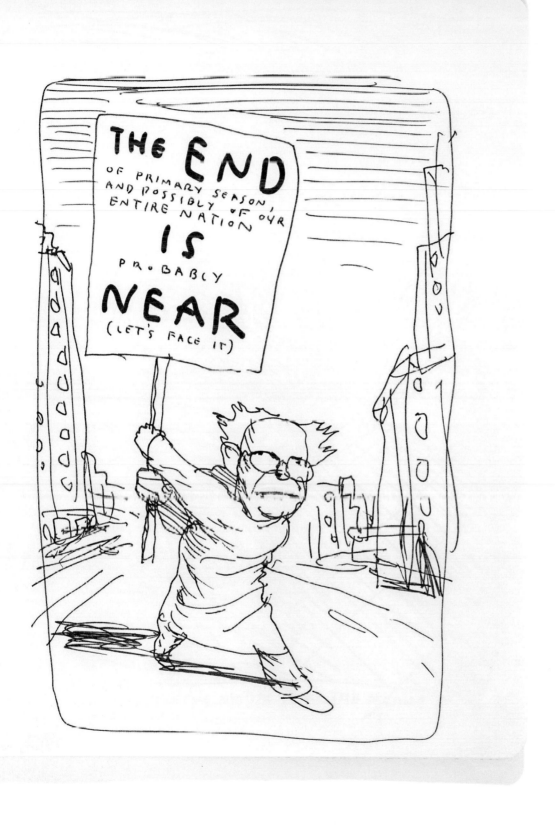

Bernie, I'll miss you most of all.

Opposite: Sketchbook that blew open on this page
and was photographed and included accidentally, I'm guessing

CONTRIBUTORS
(essay writers)

David Remnick is the editor of The New Yorker.

Frank Rich, a former Op-Ed columnist and chief drama critic at The New York Times, is a writer-at-large for New York magazine and executive producer of the HBO series Veep.

Steve Brodner is a leading political satirist and caricaturist. Since the 1970s, his artwork has regularly been featured in major American publications, including The Nation, Esquire, Sports Illustrated, The New York Times, The Washington Post, and The New Yorker.

Steven Heller, co-chair of the School of Visual Arts MFA Design/Designer as Author + Entrepreneur program, is the author or editor of 170 books on design and illustration and the recipient of the Smithsonian Institution National Design Award for "Design Mind."

Françoise Mouly, an artist and designer, co-founded and has published the legendary avant-garde comics magazine RAW starting in 1980. Since 1998, she's been editing, designing, and publishing kids' comics under her own Little Lit and Toon Books imprints. She has been The New Yorker's art editor since 1993.

For: Angie, Sam, Irene & Ron.

Thanks to the wonderful editors and designers who made this book: And to the essay writers

←

Geoff Kloske Courtney Young Kevin Murphy

Helen Yentus

Yo Cuomo Bonnie Briant Johno Rattman Bobbie Richardson

Also: heaping debts of gratitude to Graydon Carter, Susan Hudson, John Korpics, Patrick Mitchell, Jim Ireland, Chris Curry, Genevieve Bormes, Aimee Bell, Kelly Doe, Susan Levin, Mark Danzig, Robert Priest, Brian Rea, David Olive, Mary Parsons, Judy Garlan, Hans Teensma, Geraldine Hessler, John Macfarlane, Peter Kaplan, Paul Hodgson (this is a long list), Anne Schwartz, Lee Wade, David Harris, Tina Brown, the Hamblies, Tonya Douraghy, B.W. Honeycutt, Michael Grossman, Roy Blount Jr, Teresa Fernandes, Bob Mankoff, Joe Kimberling, Michael Picon (I really ought to have alphabetized this), Caitlyn Dlouhy, Brian McFarlane, Alan E Cober, Mark Ulriksen. And Alex Hood. And Zoe Matthiessen. And Jonah Winter.

As well as: Bob Slapcoff, Andy Morris, Joe Ciardiello, John Cuneo, Tim Bower, Anita Kunz, Sandra Dionisi, John Hassan, Nina Berkson, Wendell Minor, and Ricky Blitt, Rob Shepperson, Michael Sloan, Mark Hess, John Richardson, Doug White, Steve MacQuarrie, Steve Daitch, Blair Clark, Ieva Sabuckyté, The Philippines, The Hague, Wheat, and most fish.

Riverhead Books
An imprint of Penguin Random House LLC
375 Hudson Street
New York, New York 10014

Library of Congress Cataloging-in-Publication Data

Name: Blitt, Barry, artist.
Title: Blitt/Barry Blitt.
Description: New York: Riverhead Books, 2017.
Identifiers: LCCN 2017007774 | ISBN 9780399576669
Subjects: LCSH: Canadian wit and humor, Pictorial.
Classification: LCC NC1449.B59 A4 2017 | DDC 741.5/6971—dc23
LC record available at https://lccn.loc.gov/2017007774

p. cm.

Printed in China
1 2 3 4 5 6 7 8 9 10

Creative Director: Claire Vaccaro
Editor: Courtney Young

Art direction and book design by Yolanda Cuomo, NYC
Associate Designer: Bonnie Briant
Assistant Designer: Bobbie Richardson
Photographs and files for reproduction: Jonno Rattman and Altaimage